This book is published in celebration of the twenty-fifth anniversary of the Philadelphia Museum of Art Craft Show and is made possible by the generous sponsorship of The Women's Committee of the Philadelphia Museum of Art.

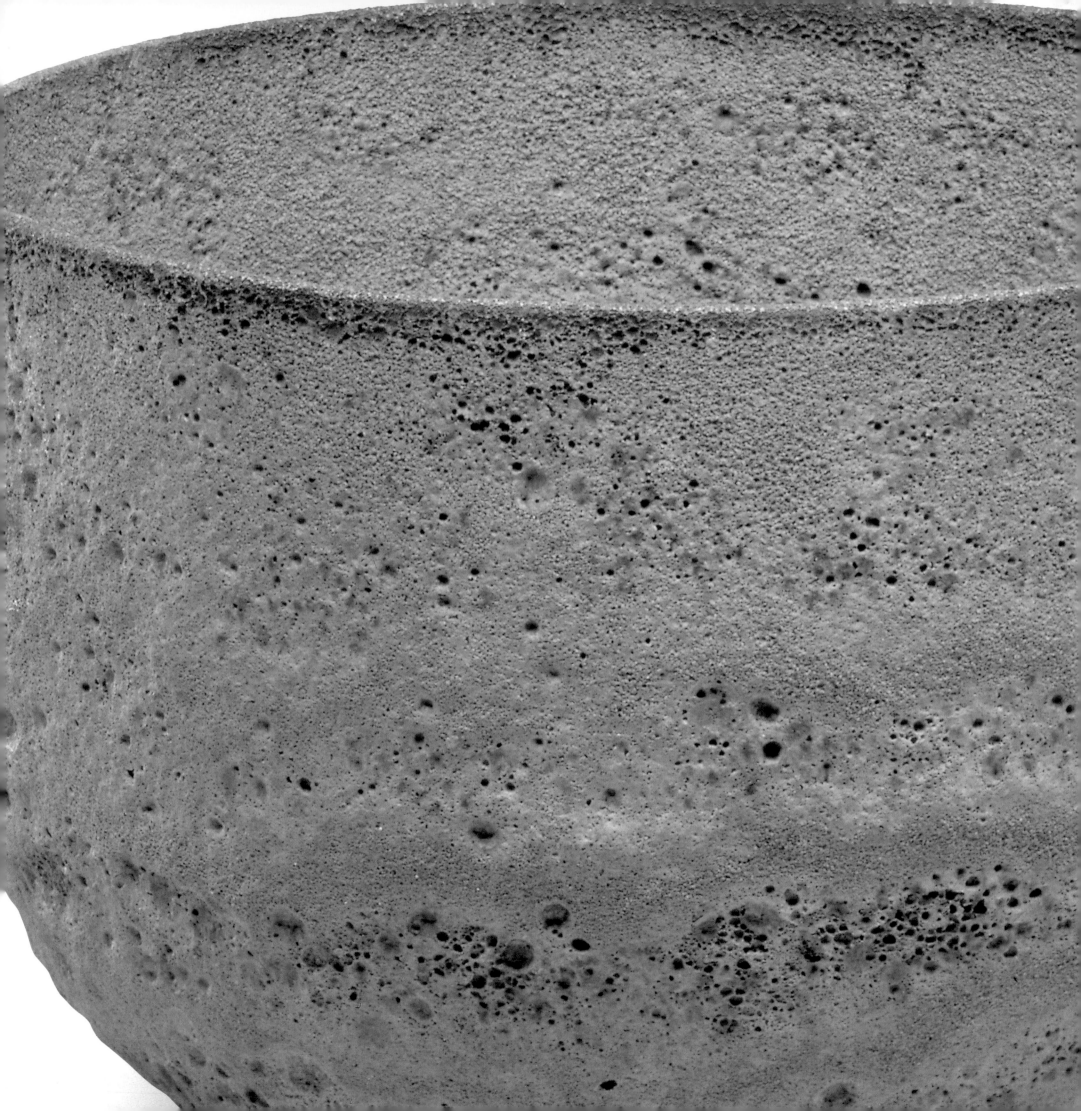

CRAFTING A LEGACY

Contemporary American Crafts in the Philadelphia Museum of Art

Suzanne Ramljak

with an introduction by Darrel Sewell

Philadelphia Museum of Art
in association with
Rutgers University Press
New Brunswick, New Jersey, and London

Jacket: *front*, Rudolf Staffel, *Bowl*, 1969 (pl. 25); *back*, James Prestini, *Bowl #107*, 1947 (pl. 101, detail)

Frontispiece: Gertrud and Otto Natzler, *Bowl*, 1946 (pl. 15, detail); page 5: Dale Chihuly, *Five Nested Glass Bowls*, before 1982 (pl. 75, detail); page 8: James Prestini, *Bowl #92*, 1950 (pl. 99, detail); pages 10–11: Chunghi Choo, *Decanter*, 1980 (pl. 84, detail); page 13: Bennett Bean, *Untitled (Double Series)*, 1998 (pl. 2, detail); pages 14–15: Dale Chihuly, *Chief Pattern Blanket*, 1975 (pl. 74, detail); pages 22–23: Sheila Hicks, *Tresors et Secrets,* 1990–95 (pl. 43, detail); page 27: Richard Marquis, *Marquiscarpa #95-9*, 1995 (pl. 79, detail of top view); page 29: Richard DeVore, *Bowl*, 1976 (pl. 4, detail); page 77: Lewis Knauss, *Field*, 1998 (pl. 44, detail); page 99: John Cederquist, *Steamer (Cabinet),* 2001 (pl. 61, detail); page 121: Toots (Mary Ann) Zynsky, *Untitled Landscape,* 1992 (pl. 83, detail); page 135: William Harper, *Pagan Baby #10: Orange Scarab,* 1978 (pl. 85c, detail); page 149: Gyöngy Laky, *Evening*, 1995 (pl. 95, detail); pages 162–63: Judy Kensley McKie, *Panther Bench*, 1982 (pl. 69); page 190: Michael Olszewski, *The Weight of Being*, 2000 (pl. 49, detail); page 191: Jun Kaneko, *Plate*, 1984 (pl. 12, detail)

Robert Arneson, *David (David Gilhooly)*, 1977 (pl. 1) © Estate of Robert Arneson/Licensed by VAGA, New York, NY

Produced by the Department of Publishing
Philadelphia Museum of Art
Edited by David Updike
Production by Richard Bonk
Designed by Eileen Boxer, Boxer Design, Brooklyn, New York
Object photography by Graydon Wood and Lynn Rosenthal
Color separations by Professional Graphics, Inc., Rockford, Illinois
Printed and bound in Belgium by Snoeck-Ducaju & Zoon

A copublication of
Philadelphia Museum of Art
2525 Pennsylvania Avenue
Philadelphia, PA 19130
and
Rutgers University Press
New Brunswick, New Jersey, and London

Library of Congress Cataloging-in-Publication Data

Philadelphia Museum of Art.
Crafting a legacy : contemporary American crafts in the Philadelphia Museum of Art/Suzanne Ramljak with introduction by Darrel Sewell.
 p. cm.
Includes bibliographical references and index.
ISBN 0-8135-3203-5 (cloth)
1. Decorative arts—United States—History—20th century—Catalogs. 2. Handicraft—United States—History—20th century—Catalogs. 3. Philadelphia Museum of Art—Catalogs. I. Ramljak, Suzanne. II. Title.

NK808 .P495 2002
745.5'0973'07474811—dc21 2002072705

CONTENTS

FOREWORD

Anne d'Harnoncourt
THE GEORGE D. WIDENER DIRECTOR
AND CHIEF EXECUTIVE OFFICER

This long-awaited book bears handsome witness to the confluence of three important strands in the history of the Philadelphia Museum of Art: the institution's strong commitment to the decorative arts and to American art since its founding; the energy and creativity of The Women's Committee of the Museum, as particularly evident in their invention of the Philadelphia Museum of Art Craft Show and its huge success over the past twenty-six years; and the alert curatorial eye and knowledge of the field of American crafts brought to the Museum with Darrel Sewell's arrival as Curator of American Art in 1973. As the Museum concludes a two-year celebration of its 125th Anniversary, the publication of this book on its American craft holdings fulfills a fundamental mission to make our distinguished and growing collections better known to a wide audience. The late Rudolf Staffel's delicate porcelain bowl illustrated on the cover affords the opportunity for a special tribute to a master among American ceramists whose art will continue to amaze and delight an international public, especially seen in such depth as in this Museum.

To all the generous donors of objects and funds that have built the collection recorded here, most especially The Women's Committee and the Craft Show Committees over the years, go our heartfelt thanks. Several of the most spectacular recent acquisitions have come as 125th Anniversary gifts, inspired by the efforts of the Committee on Collections 2001 and its zealous chairman, Harvey S. Shipley Miller. To Darrel Sewell, upon the occasion of his retirement this year as curator after a tenure of almost three decades, go the warmest good wishes of his Museum colleagues and gratitude for his informed and thoughtful commitment to superb quality. Together he and I thank Suzanne Ramljak for her fine text, which discusses many of the objects in the collection in depth for the first time, and Amanda Clifford for compiling the checklist and organizing the photography project. The book owes its striking appearance to designer Eileen Boxer, as well as Museum photographers Graydon Wood and Lynn Rosenthal and Jason Wierzbicki, Photography Coordinator. It was brought into being by the terrific team of Rich Bonk, Book Production Manager, and David Updike, Associate Editor, under the experienced eye of Sherry Babbitt, Director of Publishing.

Last, yet foremost, it is the imagination, craftsmanship, and love of their materials of the artists themselves that we collectively celebrate and salute.

PREFACE

Judy C. Pote

**PRESIDENT, THE WOMEN'S COMMITTEE OF THE
PHILADELPHIA MUSEUM OF ART**

The Women's Committee of the Philadelphia Museum of Art was formed in 1883, a mere seven years after the founding of the Museum itself, with twenty-seven original members who were concerned primarily with planning festivities, organizing modest fundraising efforts, and providing public relations assistance. Over the years, the Committee has both increased its membership, which now numbers forty-five, and greatly expanded its scope of activities and its financial gifts to the Museum. The Committee's fundraising efforts have gone toward enhancing the Museum's collections, establishing curatorial chairs and funding curatorial salaries, renovating the Museum building, installing new computers and equipment, underwriting exhibitions, and launching the popular Wednesday Night at the Museum series. The Women's Committee also provides ongoing funding for the Museum Guide program, accessible programs for people with disabilities, and fresh flowers for the Great Stair Hall. Past projects include publishing a cookbook, *The Fine Art of Cooking*, and adopting an inner-city school. By far, however, the largest project undertaken by The Women's Committee has been the annual Philadelphia Museum of Art Craft Show.

The Craft Show had its origins in a 1974 exhibition and sale of handmade jewelry called *A Touch of Gold*, organized by The Women's Committee. The great success of this event convinced the Committee to host an annual craft show as a fundraiser for the Museum. In November 1977 the first Philadelphia Museum of Art Craft Show was held at Memorial Hall, bringing craft artists and collectors from around the country to Philadelphia and netting $25,000 for the Museum. Over the years, the show moved from Memorial Hall to the 103rd Engineers Armory to the Philadelphia Civic Center before settling in its current home, the Pennsylvania Convention Center, in 1994. Held every November, the Craft Show has become the single largest annual fundraising event for the Museum. In 2001 the Craft Show netted $405,000, and its cumulative twenty-five-year contribution to the Museum is $6 million, with a portion of each year's profits designated for the acquisition of contemporary American crafts. It has also come to be considered the finest craft show in the country, with a

reputation for bringing together the highest level of artists and an educated, discerning audience.

As the Craft Show grew in size and scope, a separate committee was formed under the auspices of The Women's Committee to oversee the event. The Philadelphia Museum of Art Craft Show Committee is made up of about a hundred marvelously energetic and dedicated volunteers who work hard all year to make the show in November such a success. We receive more than 1,500 applications each year from artists across the country. In the spring, five knowledgeable professionals in the field—craft artists, gallery owners, collectors, and curators—have the very difficult job of selecting the nearly two hundred artists who will be included in the show. The Committee also seeks to honor the contributions of leading craft artists through its Award for Distinguished Achievement. Past recipients of the award include Rudolf Staffel, Harvey Littleton, Sam Maloof, and Beatrice Wood, all of whom are represented in the pages of this book.

It has long been a goal of The Women's Committee to publish a scholarly book on the Philadelphia Museum of Art's fine collection of contemporary American crafts. We have many people to thank for this publication, the purpose of which is to honor and recognize the artists represented in the collection. Anne d'Harnoncourt, the George D. Widener Director and Chief Executive Officer of the Museum, has always been behind all of our projects. Darrel Sewell, the Robert L. McNeil, Jr., Curator of American Art, whom we consider "our curator," has over the years helped to assemble the impressive collection on display here. We are also very grateful to have been able to enlist one of the leading scholars in the field, Suzanne Ramljak, to contribute an essay and write the catalogue entries. Eileen Boxer of Boxer Design gave the collection the elegant treatment it deserves in these pages. Sherry Babbitt, Director of Publishing at the Museum, and David

Updike, Associate Editor, worked tirelessly to make this book happen. Nancy O'Meara, Craft Show Manager, in addition to her myriad duties as negotiator, organizer, and promoter of the show, also helps keep the rest of us on our toes. Last, but certainly not least, we would like to thank the entire Craft Show and Women's Committees, past and present, for a job well done.

We hope you will visit the Philadelphia Museum of Art to see our collections firsthand, and that you will always remember to attend the Philadelphia Museum of Art Craft Show in November. It is with pleasure that The Women's Committee has sponsored the publication of this book. Enjoy it!

A LEGACY OF CRAFTS

CONTEMPORARY CRAFTS IN
THE PHILADELPHIA MUSEUM OF ART

Darrel Sewell

THE ROBERT L. McNEIL, JR., CURATOR OF AMERICAN ART

Contemporary crafts were among the first objects to enter the collections of the Philadelphia Museum of Art when it was founded in 1876. The expansive displays of human achievement and creativity at the Centennial Exposition in Philadelphia that year—the first of the great international exhibitions to be held in the United States—had a profound influence on American culture. Describing the impact of the Centennial, one perceptive critic recalled: "the pictures and marbles of Europe, the stuffs and brasses and carvings of India, the keramics [sic] of the Flowery Kingdom, the grotesque lovelinesses and the majestically splendid trifles of Japan, flung their challenge in the face of Yankee steam and steel, and said, (with none to contradict), *You are a means towards living: we are an end to live for.*"[1] Inspired by a new awareness that American goods had to compete aesthetically—as well as in their inventiveness and soundness of manufacture—in an international market, the founders of the Museum joined it to a school for training students who would improve the appearance of mass-produced goods of all kinds.

The collections of this new Pennsylvania Museum and School of Industrial Art were intended to serve as examples of design and technique for pupils in the school, reflecting a conviction that good design began with a thorough knowledge of hand-crafted works of the past. As a result, the Museum's first acquisitions were primarily ceramics, glass, metalwork, furniture, and textiles as well as architectural models and casts of architectural elements (fig. 1). These were variously referred to as "decorative arts," "useful arts," "industrial arts," and occasionally "handicrafts," but the existence of a hierarchy dividing these categories from painting and sculpture was vigorously denied: "where lies the line of division? In truth, there is none; the same fundamental principles govern all—it is in only comparatively modern times that dividing lines have been drawn, to the loss of both the 'Major' and the 'Minor' arts."[2] A few paintings were donated in the early years, but paintings did not reach significant numbers in the Museum until Mrs. W. P. Wilstach bequeathed 155 paintings and an endowment for future acquisitions of painting and sculpture to the city in 1893.

Many of the contemporary craft objects purchased in 1876, mostly from the exhibitions at the Centennial, were modern renditions of traditional ethnic handwork or

factory-made replicas utilizing new techniques, such as the reproductions of vessels of bronze and other metals produced by the electrotyping process. Others were hailed as examples of innovative design, such as the Renaissance-style porcelain ewer and stand designed and painted in 1875 by the English artist Thomas John Bott, Jr., with a scene of the Triumph of Scipio after the sixteenth-century Italian artist Perino del Vaga, done in the manner of Limoges enamels.

The acquisition of objects of all kinds continued for the next fifty years, and additions of ceramics and glass especially were enthusiastically sought by Edwin AtLee Barber, who joined the Museum in the honorary position of Chief of the Department of Archaeology in 1879 and was named Director in 1907. Barber had a true collector's enthusiasm for ceramics; his personal collection was purchased in 1892 as the nucleus of the newly founded Department of American Pottery and Porcelain. During his tenure at the Museum, he expanded the variety of ceramics collected, produced scholarly texts in the field, held exhibitions, and encouraged ceramics manufacturers to donate examples of their work. Barber collected some of the most advanced work in contemporary ceramics and glass from Europe and the United States, and by the time of his death in 1916 the Museum owned major examples by Marc-Louis-Emmanuel Solon for Mintons, Ltd., Kataro Shirayamadani for Rookwood Pottery (fig. 2), Louis Comfort Tiffany, and Emile Gallé, among others. These unique objects by celebrated artists foreshadowed the craft revival that would occur after mid-century. Apparently Barber's taste did not extend to contemporary work in other mediums, however, nor did that of other

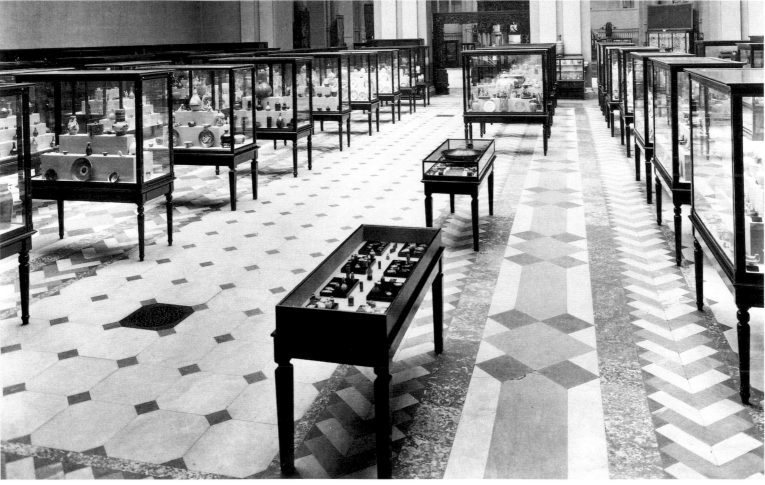

FIG. 1. CERAMICS DISPLAYED IN THE ASIAN ART GALLERY IN MEMORIAL HALL, HOME OF THE MUSEUM FROM 1876 TO 1928

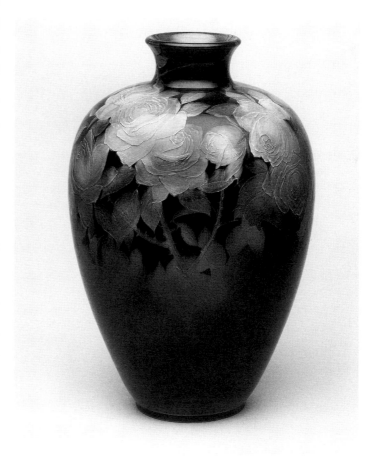

collectors, teachers, and curators attached to the Museum. Except for ceramics and glass, other work in modern styles such as Arts and Crafts, Mission, and Art Nouveau were not acquired.

Two competitive crafts exhibitions were held during Barber's tenure—of pottery and porcelain in 1888, and of pottery, porcelain, glass, terra cotta, tiles, stained glass, and mosaic in 1889—and works by students in the school were displayed regularly in the Museum and illustrated in its *Annual Report* and *Bulletin*. But it was not until 1922 that the first exhibition devoted to contemporary crafts was held. The *Bulletin* for January 1923 commented on the success of the *Exhibition of American Handicrafts* assembled by the American Federation of Arts and remarked, "One of the foremost aims of museum service is to give the modern craftsman a source of inspiration for better and truer work; yet the service is but half fulfilled if, after assembling for his benefit the best examples of workmanship of past ages, we neglect to encourage the worker of today by exhibiting and criticizing the results of his efforts. For our Museum particularly, with its associated School of Industrial Art, the importance of this fact cannot be longer overlooked."[3]

As these words were written, a new Museum building, begun in 1919, was rising on Fairmount, and the new structure effected a dramatic change in collecting goals. Construction was spurred by three important groups of paintings—the William L. Elkins, George W. Elkins, and John H. McFadden collections—which had been donated with the stipulation that they be installed in the new building by a specific deadline, as well as by the prospect of housing the John G. Johnson Collection of paintings, which had been bequeathed to the city in 1917. These alone would have changed the character of the displays in the Museum radically. However, the new Director, Fiske Kimball, appointed in 1925, conceived the idea of devoting the entire second floor of the building to a historical survey incorporating architec-

tural elements to provide settings for objects of all kinds, arranged in "a chronological and geographical evolutionary order covering the history of art since the beginning of the Christian era"[4] (fig. 3). Such a goal implied a more systematic and wide-ranging acquisition policy, more stringent evaluation of objects in terms of quality, and consideration of their place in the overall scheme of presentation. Although in theory the new Museum would serve the art school even more effectively, the relation between the school and the collections would be less direct.

Contemporary art was not excluded from the scope of the Museum, but no provision was made for it in the historical arrangement of the second-floor architectural settings, and the contemporary works added were mostly paintings, sculpture, and graphic arts. Surveying the strengths and

FIG. 2. *VASE*, 1899, MADE BY ROOKWOOD POTTERY, CINCINNATI, OHIO, AND DECORATED BY KATARO SHIRAYAMADANI (JAPANESE, ACTIVE UNITED STATES, 1865–1948). EARTHENWARE WITH UNDERGLAZE DECORATION; HEIGHT 17³/₈ INCHES (44.1 CM). GIFT OF JOHN T. MORRIS, 1901-15

weaknesses of the collections nearly twenty years after he had assumed the directorship, Kimball described the Museum's representation of twentieth-century works as being "very strong, except in decorative arts, which are almost totally lacking."[5] There may have been a plan to build a contemporary collection, however, for in 1929, when the Modern Club of Philadelphia donated a wooden buffet designed in the Art Deco style by Eugene Schoen (fig. 4), it was celebrated as "the first link toward a collection of modern decorative arts … [that] is particularly welcome owing to the lack of any example of this period in the Museum's permanent collection."[6] And several exhibitions of contemporary crafts and design were in fact shown at the Museum in the late 1920s: the *Loan Exhibition of Modern Decorative Arts* of 1926 (an abbreviated version of the *Exposition Internationale des Arts Décoratifs et Industriels Moderne* held in Paris in 1925), the *International Exhibition of Ceramic Art* of 1928, and the *International Exhibition of Glass and Rugs* of 1930. However, acquisitions in these fields over the next several decades were scarce, the Natzler ceramics acquired in 1945 (pl. 16, checklist 49–52) and the printed textiles by June Groff acquired in 1948 (checklist 129–32) being noteworthy exceptions.

Kimball's assessment of the situation of twentieth-century decorative arts in the Philadelphia Museum of Art in 1944 remained accurate twenty years later, although the collections of early modernist painting and sculpture had been given spectacular impetus by the addition of the Louise and Walter Arensberg and A. E. Gallatin collections in 1950 and 1952, respectively, and the Museum had purchased its first

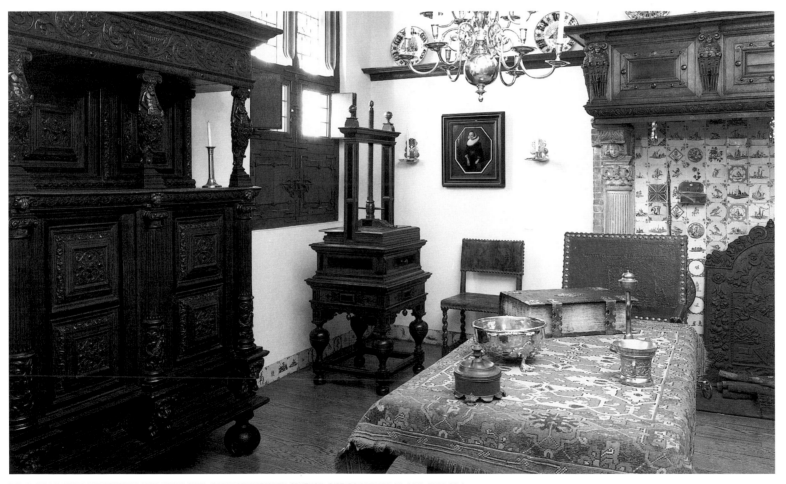

FIG. 3. *ROOM FROM HET SCHEEPJE (THE LITTLE SHIP)*, EARLY SEVENTEENTH CENTURY. GIFT OF EDWARD W. BOK, 1928-66-1. THIS DUTCH ROOM, FROM A HOUSE IN HAARLEM, WAS INSTALLED ON THE SECOND FLOOR OF THE MUSEUM'S NEW FAIRMOUNT BUILDING, WHICH OPENED IN 1928.

Abstract Expressionist painting, *Lumen Naturale* by Hans Hofmann, in 1963.

These same two decades after World War II had witnessed the emergence of the contemporary crafts movement in the United States. Art objects in the traditional craft media of ceramics, fiber, glass, metal, and wood metamorphosed from workshop or factory production utilizing traditional designs and techniques to the productions of independent artists who took what they wanted from the techniques or philosophies of traditional crafts but interpreted them in an original way that was responsive to other currents of contemporary art. To recognize this new development, the American Craft Council founded the Museum of Contemporary Crafts (now the American Craft Museum) in New York in 1956.

By the mid-1960s, Philadelphia had become a vital center for contemporary crafts, largely due to the expanded programs of its many distinguished art schools, including the Tyler School of Art of Temple University, Moore College of Art, Philadelphia College of Art (now the University of the Arts), Philadelphia College of Textiles and Science (now Philadelphia University), and Drexel Institute of Technology (now Drexel University). Seeing a need to publicize this quiet renaissance, gallery owner Helen Drutt, with support from Rev. Richard Jones, founded the Philadelphia Council of Professional Craftsmen in 1967, bringing together the city's craft artists—many of whom were faculty members at the schools. Major exhibitions of contemporary crafts were held at the Philadelphia Civic Center in 1967, 1970, and 1973, and the landmark survey of contemporary crafts, *Objects: USA*, was shown at the Civic Center in December–January 1971–72.[7]

At the Museum, the Inter-Society Committee for 20th-Century Decorative Arts and Design (now known as Collab: The Group for Modern and Contemporary Design at the Philadelphia Museum of Art) was founded in 1970 "to bring together for the Philadelphia public a first-rate, full collection of this century's masterpieces of decorative arts and design."[8] In November of that year, the Museum opened an exhibition of objects acquired through the Committee's efforts, including works by Rudolf Staffel (pl. 25, checklist 78–81), Olaf Skoogfors (pl. 92), Raymond Gallucci (checklist 26), Paula Winokur (checklist 111), and Roland Jahn (checklist 219). Succeeding years have brought additional examples by Staffel, Dominick Labino (pl. 76, checklist 221–32), Karel Mikolas (checklist 239–41), and Ruth Duckworth (pl. 7, checklist 21–23), among many other gifts of twentieth-century American and European design and craftsmanship.

The creation of curatorial positions for twentieth-century art and American art in 1971 allowed the Museum to begin to make a wider study of contemporary American crafts. Works as varied as *David* by Robert Arneson (pl. 1), the

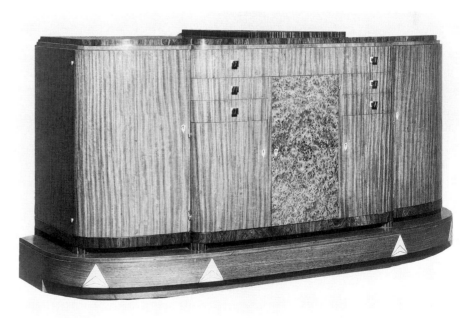

FIG. 4. EUGENE SCHOEN (AMERICAN, 1880–1957), *BUFFET WITH BASE*, 1927. BUFFET: WALNUT, OAK, BUBINGA AND IMBUA BURL, MACASSAR EBONY, AND ROSEWOOD; BASE: WALNUT WITH HOLLYWOOD INLAY. GIFT OF THE MODERN CLUB OF PHILADELPHIA, 1929-45-1A, B

Music Stand by Wendell Castle (pl. 59), and the *Vessel* by William Daley (pl. 3) were added in the mid-1970s. The Museum's Bicentennial exhibition, *Philadelphia: Three Centuries of American Art*, provided an opportunity to place the creative vitality and remarkable transformations in the work of the city's contemporary craft artists in a historical context (fig. 5).

Certainly the most important event for the Museum's collection of contemporary crafts has been the annual Philadelphia Museum of Art Craft Show (fig. 6), organized and launched in 1977 by The Women's Committee of the Philadelphia Museum of Art, which has been devoted to supporting the programs and collections of the Museum since the group was founded in 1883. In its early years the Committee's efforts were largely devoted to providing for the

comfort and health of the students of the school and raising money for prizes and scholarships. Even then, however, there was evidence of interest in contemporary ceramic arts: a member of The Women's Committee organized an exhibition of Rookwood pottery for the school in 1900.

Prior to the Craft Show, The Women's Committee had raised hundreds of thousands of dollars to benefit the Museum. The Craft Show was its first sustained project, and it quickly gained recognition as one of the outstanding exhibitions of its kind in the United States. It has raised millions of dollars for the Museum in its twenty-five years. Since 1981, a portion of the proceeds has been donated for the purchase of contemporary American crafts, allowing the collection to grow steadily. To celebrate the fifteenth anniversary of the Craft Show in 1991, The Women's Committee sponsored

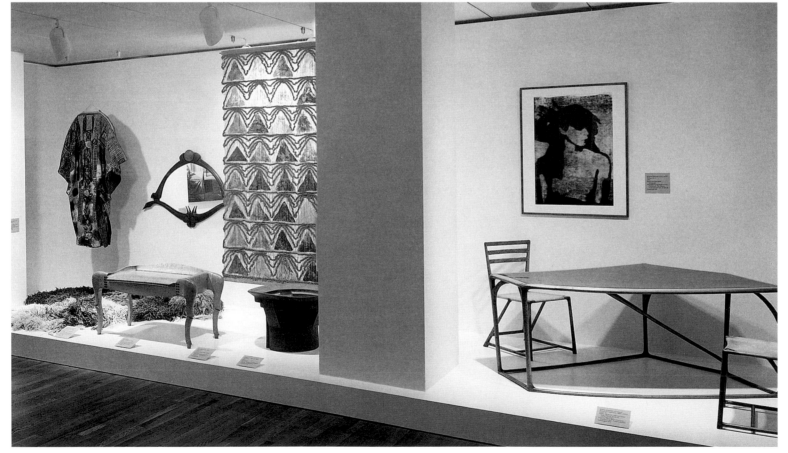

FIG. 5. A CONTEMPORARY AMERICAN CRAFTS INSTALLATION AT THE MUSEUM'S BICENTENNIAL EXHIBITION, *PHILADELPHIA: THREE CENTURIES OF AMERICAN ART*, APRIL 11–OCTOBER 10, 1976. SHOWN, LEFT TO RIGHT, ARE YVONNE BOBROWICZ, *FLOORSCAPE*, 1974–76; LOUISE TODD COPE, *WALKING QUILT*, 1973–74; DANIEL JACKSON, *PIANO BENCH*, 1970, AND *LOOKING GLASS (LEDA, THE DEVIL, AND THE MOON)*, 1973 (CHECKLIST 187); H. THEODORE HALLMAN, *L'ÉGYPTIEN*, 1965 (CHECKLIST 133); WILLIAM DALEY, *FLOOR POT*, 1974; WHARTON ESHERICK, *TABLE AND CHAIRS*, 1939–40

research and publication of a Museum *Bulletin* devoted to the craft collection, which at that time numbered 148 objects.

A prime motivating force for both the Philadelphia Museum of Art Craft Show and the Museum's craft collection has been the conviction and dedication of Mrs. Robert L. McNeil, Jr. A member of The Women's Committee since 1963, she has chaired the Craft Show Committee and continues to serve on its board of directors. In other craft-related endeavors, Mrs. McNeil chaired the *Craft Art and Religion* exhibition held at the Vatican in 1978 and was named a trustee of the American Craft Council in 1978, a position she held until 1982, continuing as a trust emerita. She also has been the major private donor to the Museum's collection of contemporary crafts; her fine taste as a collector and generous support of craft acquisitions are evident in the pages of this catalogue.

With a substantial and growing collection supported by The Women's Committee to serve as a lodestone, gifts and purchases from other sources have been attracted to the Museum. In 1989, the Museum acquired its largest example of contemporary American crafts to date: the library fireplace and the entire wood-paneled music room designed by Wharton Esherick for the Curtis Bok house in about 1936–37 (pls. 62–64), a purchase largely funded by the generosity of W. B. Dixon Stroud. A masterpiece by an artist celebrated as a pioneer in the field, the Esherick woodwork marks the chronological beginning of the Museum's collection of contemporary crafts as the art is understood today.

The Bok music room brings the Museum's period interiors into the twentieth century, updating Fiske Kimball's plan to use architectural elements to present historically related objects. It symbolizes the renewed commitment to the collecting of contemporary crafts that distinguished the Philadelphia Museum of Art in its earliest days. Today, contemporary American crafts at the Philadelphia Museum of Art number 315 acquisitions, and like the Craft Show that has made it possible, the collection looks forward to a future of continued growth and improvement, with the goal of becoming the best in existence.

NOTES

This essay is adapted and expanded from Darrel Sewell, "Contemporary Crafts and the Philadelphia Museum of Art: A Brief History," in *Contemporary American Crafts: Philadelphia Museum of Art Bulletin* 87, nos. 371–72 (1991), pp. 4–7.

1. Mariana Griswold van Rensselaer, *Book of American Figure Painters* (1886; reprint, New York and London: Garland Publishing, 1977), n.p.
2. Huger Elliott, "Aims and Methods in the School," *Pennsylvania Museum Bulletin* 17, no. 67 (February 1921), p. 28.
3. "American Handicrafts Exhibition," *Pennsylvania Museum Bulletin* 18, no. 73 (January 1923), p. 15.
4. Fiske Kimball, "Report of the Director of the Museum," *Sixty-eighth Annual Report of the Philadelphia Museum of Art for the Year Ended May 31, 1944, with the List of Members* (1944), p. 13.
5. Ibid., p. 17.
6. Joseph Downs, "A Buffet in the Contemporary Style," *Pennsylvania Museum Bulletin* 24, no. 126 (March 1929), p. 19.
7. See Lee Nordness, *Objects: USA* (New York: Viking Press, 1970).
8. Calvin S. Hathaway, "One Good Turn Deserves Another; or, Help Keep the Wheel Spinning," Collab Papers, Department of European Decorative Arts after 1700, Philadelphia Museum of Art.

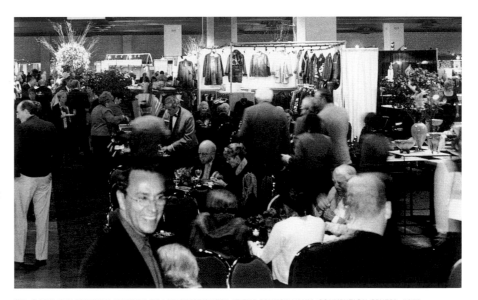

FIG. 6. THE PHILADELPHIA MUSEUM OF ART CRAFT SHOW AT THE PENNSYLVANIA CONVENTION CENTER, 1999. PHOTO BY KELLY AND MASSA

NECESSARY LUXURIES

ON THE VALUE OF CRAFTS

Suzanne Ramljak

Many questions can be posed in relation to contemporary crafts. For years, discussion in the field centered on whether crafts are art and how they might legitimate themselves by gaining recognition from the world of so-called fine art. Tied to this debate was the question of functionality, specifically, whether lack of utility brought a craft object closer to art's "useless" status. This inbred argument fortunately has subsided after failing to yield any satisfactory conclusions. More far-reaching issues now demand our attention, among them the question of why we need crafts at all and what purpose they serve in our lives. Such an inquiry requires that we consider what crafts *do,* rather than what they *are* in any essential sense. It also involves stepping out of the art/craft dichotomy and seeking rationale within other intellectual disciplines.

The term *crafts* is commonly understood to denote handmade objects, usually with a utilitarian format, made of the five traditional craft mediums—ceramic, fiber, glass, metal, and wood. While magazines, museums, and even this book still enlist such categorization, it does not do justice to the diversity of objects being produced under the rubric of crafts. Whereas most craft objects do employ these materials and are made by hand, many works—such as Joyce Scott's beaded structures (pl. 53)—straddle materials and processes or break with traditional formats. Some artists—including metalsmith Stanley Lechtzin (pl. 86), who virtually abandoned handmade production for computer-aided design and manufacture in the late 1980s—would even maintain that making goods by hand is an outmoded form of production that need not be perpetuated. Indeed, the efficacy of a craft object lies, not just in the fact that it was handmade, but also in its concept or design; its potency transcends technique or medium.

To better appreciate the value of crafts, it is useful to recall the original meaning of the term. The root of the word *craft* dates back to Old English and signifies power or might. This initial meaning is still employed in Wicca or witchcraft, wherein "The Craft" refers to the power of magic. The notion of magic (albeit in a less mystical form) can also be applied to the craft field, especially to trompe l'oeil works such as Wendell Castle's *Table with Gloves and Keys* (pl. 58) or Richard Shaw's *Walking Skeleton* (pl. 22), which involve visual trickery and the suspension of disbelief. There is also an element of magic or sleight of hand in all craft works in which the maker

exercises a transformative power—changing raw matter into form. This aspect of craft brings to the fore the other, largely suppressed, meaning of the word, as "crafty" or cunning. Such traits are typically viewed in a negative light, but they can be seen as redeeming features as well. To be crafty requires mental resourcefulness, not just technical skill. It also involves being manipulative in the best sense of the word, forcing us to see and act in ways we may not have anticipated.

In order for something to qualify as craft, it must be *crafted,* handled, physically altered. Whereas a readymade or found object could easily qualify as art, it could not be accepted as craft. Craft objects are the byproduct of physical and psychological investment. Usually labor intensive, they are also endowed with their maker's aspirations. Crafts engage us through their physical presence and manifest desire. While there is no direct correlation between the amount of time the artist spends making a work and the amount of satisfaction a viewer derives from it, there is certainly a connection between a craftsperson's devotion and a beholder's experience. Centuries after the speakers of Old English coined the word, the importance of crafts is still rooted in their power—in their capacity to move and involve us.

It may seem unnecessary to be making a case for contemporary crafts; their value should be obvious. Finely crafted objects have been part of civilization for millennia, and their attraction has not diminished with time. Nonetheless, in our own culture several factors have cast the importance of such objects in doubt. We live in a climate where all of the arts are now on the defensive, forced to uphold their honor against accusations of frivolousness or indecency. Recent history also has assigned crafts a dubious status; they are suspect for their ties to ornamentation and an inherent desire to please. In a peculiar reversal of values, we have come to respect art objects that are unsettling rather than pleasing, and crafts, along with decorative arts, are thus guilty of being agreeable. As cultural historian Wendy Steiner explains, "The aesthetic symbolism of ornament involves a gesture of 'pleasing.' . . . It is part of the ideology of charm, the use of beauty to exert power through pleasing. The contradictions of this gesture, which gains power over another by fulfilling the other's desire, has produced an age-old history of disgust and anger."[1]

Like decorative arts or ornament, many craft objects "exert power through pleasing." In *The Language of Ornament,* James Trilling locates pleasure at the root of all decoration: "Unconstrained by the need to function in the physical sense, ornament is intended, first and last, to give pleasure."[2] Trilling further holds that "there is no place for 'necessary' and 'unnecessary' in decorative art, only for pleasure,"[3] an adage that is demonstrated by many works in the Philadelphia Museum of Art's collection, from Bennett Bean's richly embellished bowls (pl. 2) to Richard Marquis's intricately patterned murrine glass (pl. 79). Although pleasing objects have come to be viewed with suspicion, pleasure remains a basic need; we are biologically programmed to seek pleasurable encounters and to avoid painful ones. As Oscar Wilde tersely declared: "Pleasure is the only thing one should live for."[4] Given the aesthetics of discomfort that have dominated much of twentieth-century art, decorative arts and crafts have become a form of guilty pleasure—more like a rich dessert than a mainstay in our lives. The argument for crafts must therefore redeem pleasure as well as speak to the larger human needs that craft objects fulfill.

The value of crafts as agents of pleasure assumes greater importance in the context of psychology and theories of cultural repression. Sigmund Freud postulated that we are all engaged in a lifelong struggle between the pleasure principle and the reality principle, wherein our quest for satisfaction is constantly being thwarted and frustrated by practical mandates. As summarized by Norman O. Brown, "man's desire for happiness is in conflict with the whole world. Reality imposes on human beings the necessity of renunciation of pleasures; reality frustrates desire."[5] Within this psychological scenario, the function of art "is to help us find our way back

to sources of pleasure that have been rendered inaccessible by the capitulation to the reality-principle, which we call education or maturity."[6]

According to Freud, only works endowed with wit and fantasy have this catalyzing potential. These traits are impervious to the dictates of reality and thus constitute the sole domain of mental freedom. By arousing our desire and imagination, an engagingly crafted object imbued with elements of fancy can help reunite us with lost pleasures. Such fancifulness is found in many works in this collection, from Judy Kensley McKie's *Panther Bench* (pl. 69) to David Gilhooly's extravagant *Osiris Vegefrogged* (pl. 9). Fantasy and imagination—whether expressed pictorially or formally—represent the realm of the "uncalled for"; they are optional features that are superfluous to a work's structure or utility but essential to its character and potency. Like ornament, the ultimate function of such fantastic objects is to give us pleasure and delight and to help reconcile us with our daily lives.

Moving beyond the question of pleasure and repression, a biological case for the importance of crafts and other highly invested objects can be found in the writings of Ellen Dissanayake. While she speculates about the function of all arts, Dissanayake's theory seems especially pertinent to craft objects. Arguing from an evolutionary or "species-centered" perspective—she accordingly dubs our race *Homo aestheticus*—Dissanayake considers how we have evolved to require art objects and what role they play in ensuring the survival of our species. She locates the essence of all art-making—"the biological core of art, the stain that is deeply dyed in the behavioral marrow of humans everywhere"—as the act of "making special."[7] Making objects special through processes such as embellishing and patterning ultimately helps cultures to cohere and function. According to Dissanayake, "Groups whose individual members had the tendency to make things special would have had more unifying ritual ceremonies, and thus these individuals and groups would have survived better."[8] This is especially true of objects or implements that were used for survival, such as tools and weapons, since the more carefully constructed and valued they were, the more likely they were to be protected and preserved. By grounding the human drive to make art in biology, Dissanayake underlines the universality of the creative tendency and provides a justification for the often elaborate works produced by craft artists. Given that many craft objects retain their functional nature, they have the potential to engage us in unifying communal activities, as Dissanayake suggests—for instance, by transforming a meal into a ritual occasion.

Contemporary craft artists represented in the Philadelphia Museum of Art's collection encompass the functional to the purely sculptural. With some exceptions, such as Robert Arneson's bust *David (David Gilhooly)* (pl. 1) or Viola Frey's still life *The Red Hand* (pl. 8), most of these works were not designed to be displayed on a pedestal; rather, they stem from traditions of utility and decoration. Even objects without apparent practical use—vessels that cannot hold liquids, textiles that cannot be worn—serve a broader function as tools for living. The fiber "soft stones" of Sheila Hicks's *Tresors et Secrets* (pl. 43), for example, cannot be employed to perform a specific task, but they are nonetheless purposeful in realigning our sensibilities and compensating for the often harsh nature of modern life. As Hicks has explained, "We need to insulate and soften our environment to make it more peaceful, creative, and livable."[9] Craft objects can thus serve as a civilizing influence, providing sensual and humane antidotes to an often insensitive and impersonal environment.

Another important function of craft objects today is to reground us in the material world. Electronic technologies such as television, computers, and video games have increasingly removed us from direct contact with material objects, replacing physical encounters with synthetic or virtual surrogates. The French philosopher Jean Baudrillard has aptly called our age the "era of hyperreality,"[10] an era marked by the reproduction and simulation of the real. Baudrillard sees the consequence of this hyperrealism as a loss of emotional investment in things, wherein "people no longer project

themselves into their objects with their affects and their representations, their fantasies of possession, loss, mourning, jealousy."[11] Another result of the decreasing tangibility of our lives is a strong disregard, if not outright hostility, toward the body and material things. "The real itself appears as a large useless body," laments Baudrillard. "This body, our body, often appears simply superfluous."[12]

Craft objects function as a hindrance to this suction into hyperreality. The role such objects can play in defying technological simulation is underlined by the etymology of the word *object.* The term derives from the Latin *obicere,* meaning to throw in the way of or hinder. As a verb, *object* means to oppose or resist. Today we require objects that can provide a form of objection to counter our own manufactured illusions. Simulated experiences are by their very nature eviscerated, and our electronic encounters remain hopelessly flat and without texture. With their insistent physicality, craft objects can act as agents of resistance to the growing intangibility of everyday life, aiding us in a program of re-embodiment.

In a time when we are surrounded by temptations to renounce the material plane, sensual objects made with personal commitment remind us that our corporeality, while inescapable, is also pleasurable. In so doing, they can renew our ties to the physical world and rekindle our desire for living. While existence is a given, living is an achievement, and we can be aided in this pursuit by material objects that exude vitality through imaginative vision or startlingly new composition. Although crafts may seem optional, they are actually crucial for our survival. Whether they are helping to unify a group, reunite individuals with lost pleasures, or provide life-enhancing stimuli, crafts offer a sophisticated form of life support. For the real sustenance in our lives there is no alternative to these rare but necessary luxuries.

NOTES

1. Wendy Steiner, *Venus in Exile: The Rejection of Beauty in Twentieth-Century Art* (New York: Free Press, 2001), p. 57.
2. James Trilling, *The Language of Ornament* (London: Thames and Hudson, 2001), p. 6.
3. Ibid., p. 189.
4. Oscar Wilde, "Phrases and Philosophies for the Use of the Young," in *The Complete Works of Oscar Wilde* (New York: Harper and Row, 1989), p. 1205.
5. Norman O. Brown, *Life against Death: The Psychoanalytical Meaning of History* (New York: Vintage Books, 1959), p. 8.
6. Ibid., p. 60.
7. Ellen Dissanayake, *Homo Aestheticus: Where Art Comes From and Why* (New York: Free Press, 1992), p. 42.
8. Ibid., p. 52.
9. Sheila Hicks, *Soft World,* exh. cat. (Tokyo: Matsuya Ginza Gallery, 1990), p. 4.
10. Jean Baudrillard, "The Ecstasy of Communication," in *The Anti-Aesthetic: Essays on Postmodern Culture*, ed. Hal Foster (Port Townsend, WA: Bay Press, 1983), p. 128.
11. Ibid., p. 127.
12. Ibid., p. 129.

Robert Arneson
Bennett Bean
William Daley
Richard DeVore
Ruth Duckworth
Viola Frey
David Gilhooly
Wayne Higby
Jun Kaneko
Michael Lucero
Ron Nagle

CERAMICS

Gertrud and Otto Natzler
William Parry
Kenneth Price
Richard Shaw
Paul Soldner
Rudolf Staffel
Toshiko Takaezu
Robert Turner
Peter Voulkos
Robert Winokur
Beatrice Wood
Betty Woodman

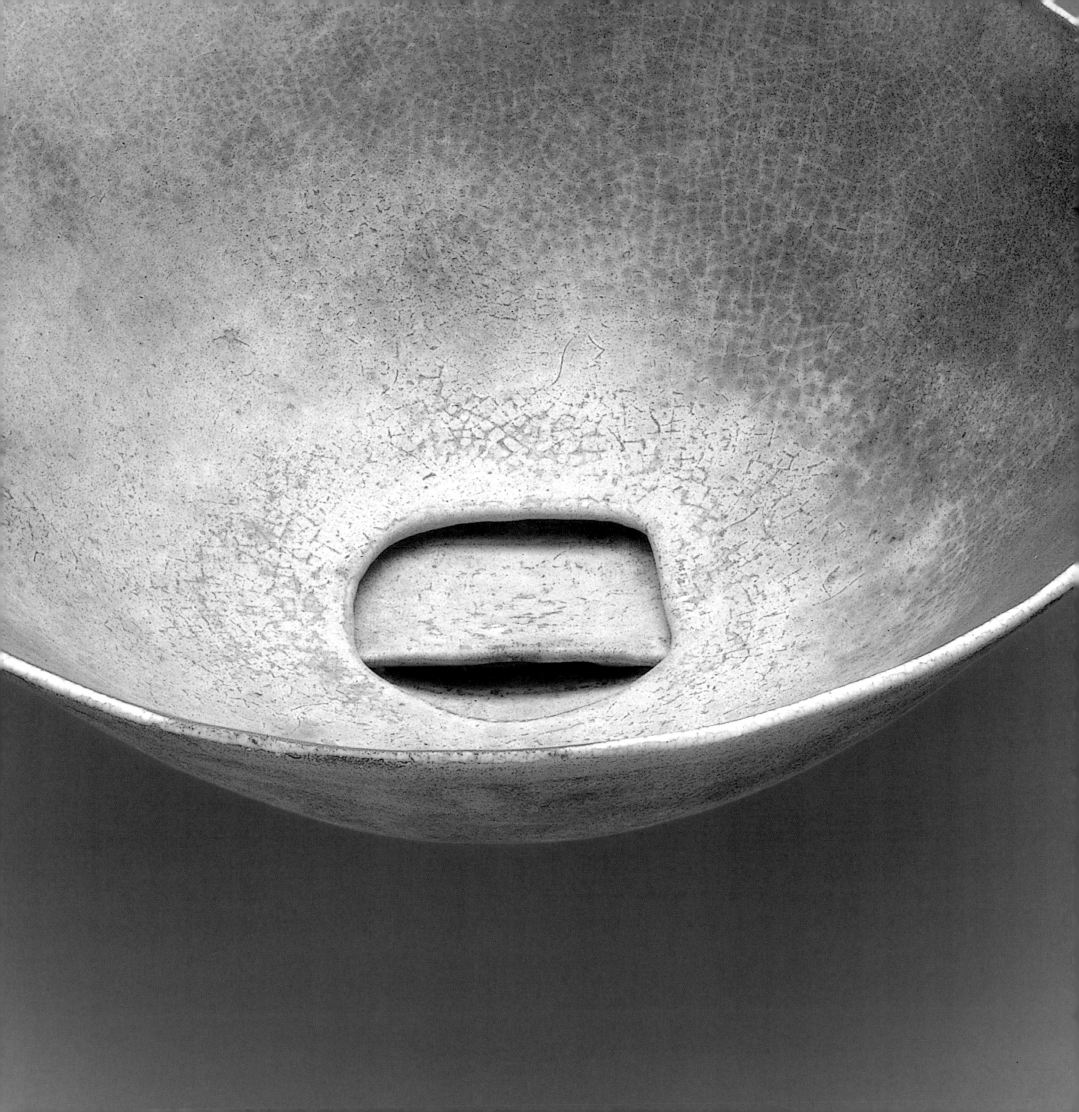

ROBERT ARNESON

Robert Arneson played a key role in the California Funk Art movement of the 1960s, and his early work partakes of the group's raucous, transgressive character. Such irreverence is exemplified by Arneson's "John" series of 1963, which features ceramic toilets with scatological embellishments, or works such as *Typewriter* (1965–66), in which protruding fingers take the place of keys. Arneson brought a similar mischievousness to his series of portrait busts begun in the 1970s. Rendered in clay instead of the traditional marble or bronze, his larger-than-life polychrome busts are credited with reviving a sculptural genre that lay dormant for much of the twentieth century.

Arneson was his own favorite subject, and his numerous self-portraits present the artist in various guises, from classical herm to winsome dog. His sculpted pantheon also includes clay portraits of art-historical personalities— among them Vincent van Gogh, Pablo Picasso, and Marcel Duchamp—that toy with the mythologies surrounding these icons.

Arneson's skill at characterization and eye for telling detail are displayed in a group of busts devoted to his artist friends in California. Personal and art-historical elements coalesce in these sympathetic and witty works. In *David* (pl. 1) Arneson conjures the likeness of David Gilhooly, his former student and assistant at the University of California, Davis. The sculpture's green glaze and the letter "F" on the cap are a nod to Gilhooly's celebrated "Frog World" series (see pl. 9). With his eyes literally glazed over, Gilhooly seems lost in his own imaginary world, dreaming up new creations.

1 DAVID (DAVID GILHOOLY)
1977
EARTHENWARE, GLAZED
HEIGHT 35 INCHES (88.9 CM)
PURCHASED WITH THE BAUGH-
BARBER FUND, 1977-126-1

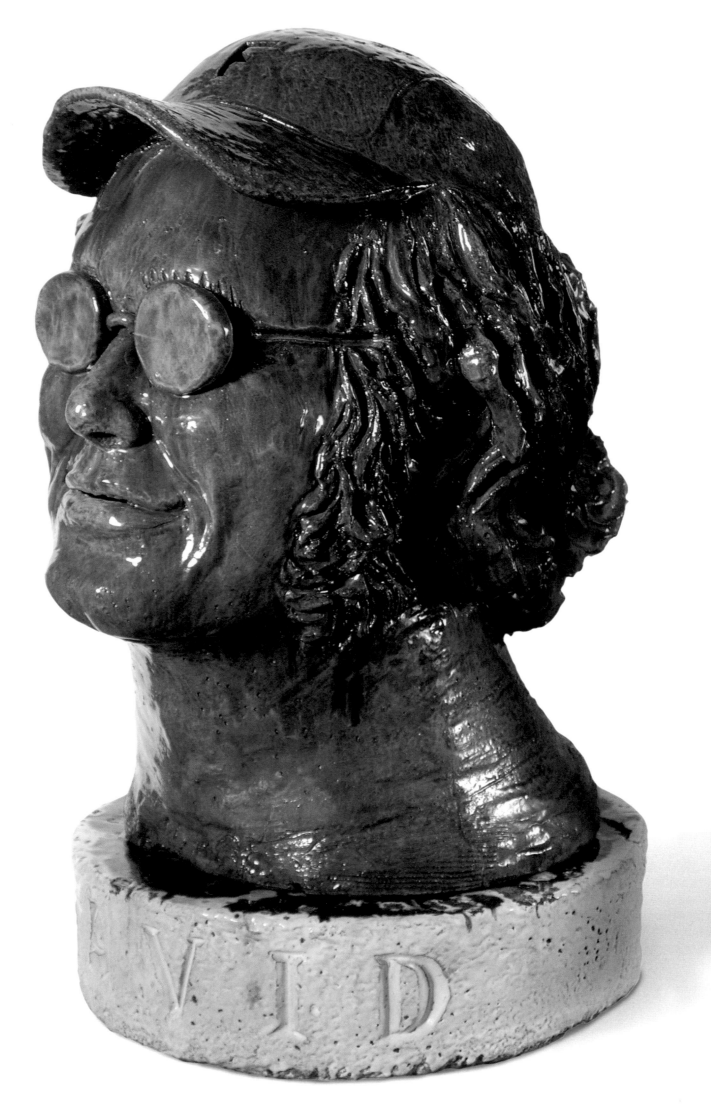

RICHARD DeVORE

Richard DeVore has remained committed to the vessel throughout his long career, extracting new vitality from this ancient form. He began exploring the possibilities of the clay vessel in the 1950s while pursuing an M.F.A. under the Finnish-born potter Maija Grotell at the Cranbrook Academy of Art in Bloomfield Hills, Michigan. His postgraduate works ranged from pinch-neck bottles to slab-built forms. By the early 1970s he had settled on the two container types that would engage him for decades: the shallow bowl and the cylindrical vase. DeVore's distinct handling of these forms reveals a unique blend of structural strength and surface vulnerability.

DeVore throws his pots on a wheel and then shapes them by hand into less symmetrical forms. Although the vessel bodies are idiosyncratic, an invisible geometry underlies their supple surfaces. He enlists the golden section, a ratio developed by the ancient Greek mathematician Euclid, to lend order and pleasing harmony to his forms. Before creating each vessel, DeVore draws a diagrammatic sketch charting its ideal proportions. The artist then reinforces this hidden geometry through carefully placed indents or punctures that align on calculated angles.

While it is common to compare vessels with the human anatomy—a connection reinforced by the potter's vocabulary of *lip, neck, belly,* and *foot*—bodily associations are especially apt with DeVore's pots. The skin-tight surfaces of his vessels gently swell around the space within; buff and rosy glazes evoke shades of flesh; and the crackle patterns suggest veins or weathered skin. As in many of DeVore's works, the taut surfaces of his 1980 *Untitled Vessel* (pl. 6) are interrupted by folds and crevices that increase the sense of containment and quiet introversion. The inward turn of the vessel's membrane draws us to the interior, and DeVore's use of a double or "fake" bottom intimates even greater depths within.

4 BOWL
1976
STONEWARE, GLAZED
DIAMETER 10½ INCHES (26.7 CM)
GIFT OF THE ARTIST, 1977-2-1

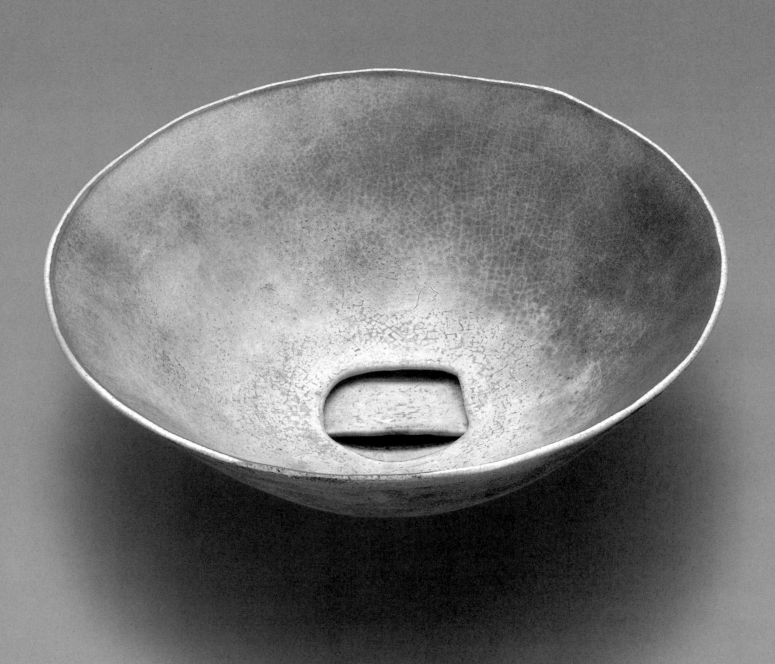

RICHARD DeVORE

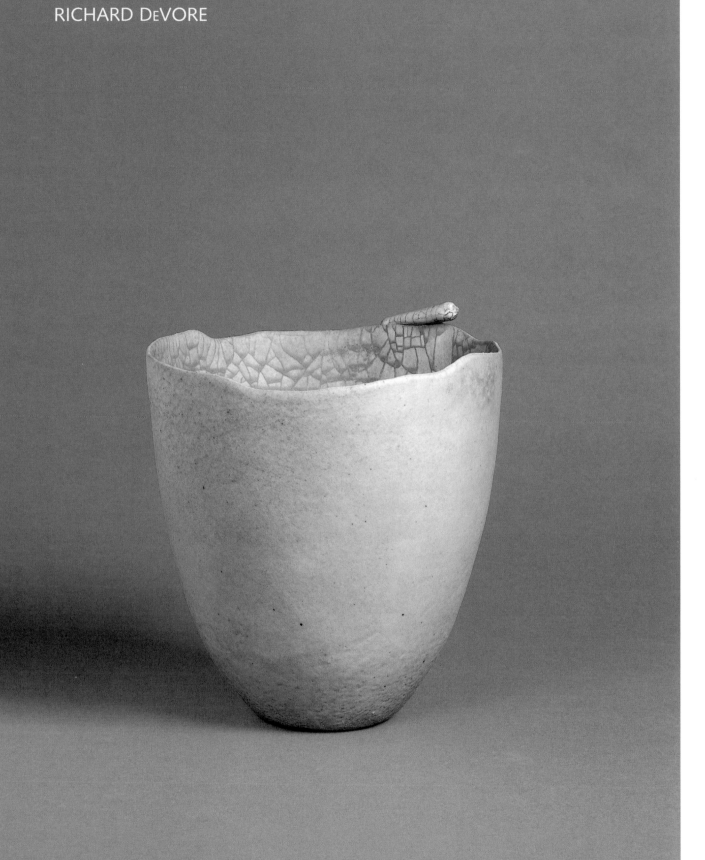

5 BOWL
1974
STONEWARE, GLAZED
HEIGHT 7¾ INCHES (19.7 CM)
PURCHASED WITH THE GEORGE W. B.
TAYLOR FUND, 1975-96-1

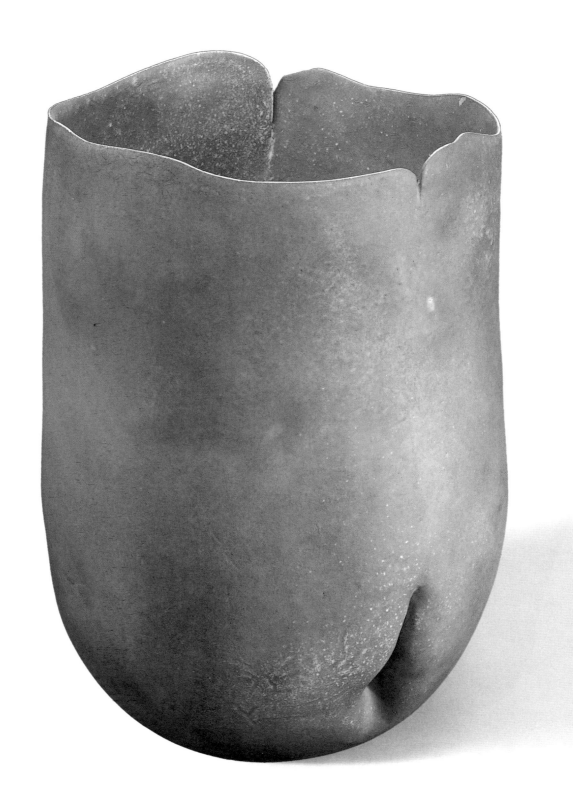

6 UNTITLED VESSEL
1980
STONEWARE, GLAZED
HEIGHT 16¼ INCHES (41.3 CM)
GIFT OF THE WOMEN'S COMMITTEE OF
THE PHILADELPHIA MUSEUM OF ART
1991-8-1

VIOLA FREY

Best known for her monumental clay figures, Viola Frey also creates assemblage compositions and highly embellished plates. Although she approaches her figurative works like an anthropologist—recording the dress and manners of middle-class folks—her assemblage works involve a more archeological approach, dredging up diverse styles, motifs, and objects. This method likely stems from a childhood spent combing trash heaps in rural California looking for discarded ceramic figurines, a foraging impulse that Frey continues to this day, frequenting flea markets in search of ceramic elements to incorporate into her art. Paraphrasing Salvador Dalí, Frey has claimed that "good art only comes from bad taste,"[1] or from sources outside of the artistic canon. Her boisterous works bear out the truth of this creative principle.

The components of Frey's expansive aesthetic emerged in the 1950s, when she studied painting and ceramics at the California College of Arts and Crafts in Oakland. It was here that she learned the hollow construction techniques that allow for the creation of large-scale clay forms. Frey continued to pursue her dual interests in ceramics and painting at Tulane University in New Orleans, where she studied with Color-Field painter Mark Rothko, earning her M.F.A. in 1958. Painting and sculpture often vie for attention in her works, with the assertive surface treatment locked in tension with the sculptural elements below. All of her works combine a vibrant, painterly surface with oversized forms and a vast iconography.

Frey refers to her assemblage works as "bricolage," a term derived from the French *bricoleur*, meaning an improvising handyman or someone who makes do with what is at hand. *The Red Hand* (pl. 8) exemplifies this approach to composition. The work features a precariously arranged still life—with plates, shell, and a flower—set on a pedestal. A looming red hand emerges cobra-like from the center. This mysterious appendage might be read as an homage to human acquisitiveness and the resourceful talents of the *bricoleur*.

1. Richard Whittaker, "Who Makes Originals, Ever? A Conversation with Viola Frey," *Works + Conversations* 4 (February 2001).

8 THE RED HAND
1983–84
CERAMIC, GLAZED
HEIGHT 62 INCHES (157.5 CM)
PURCHASED WITH THE JOSEPH E.
TEMPLE FUND, 1986-137-1

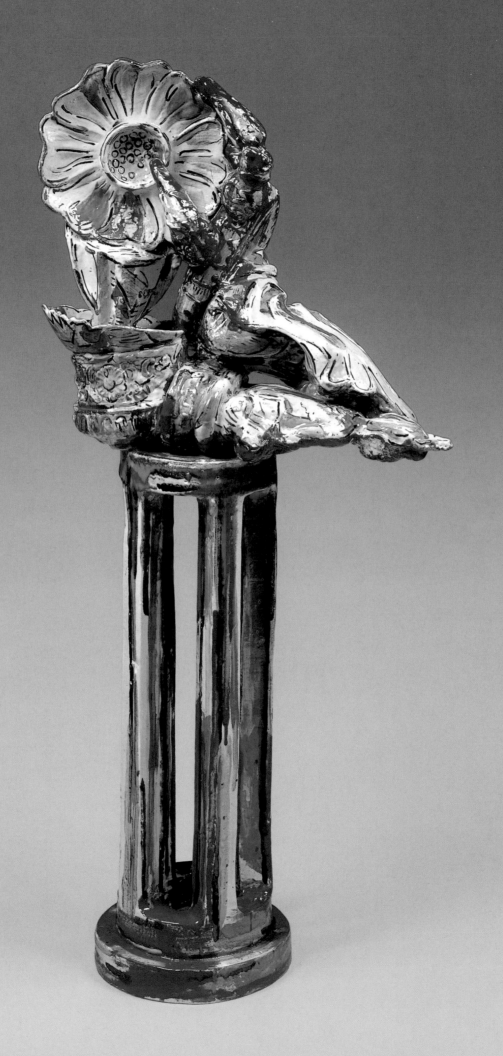

DAVID GILHOOLY

Like some mythological deity, David Gilhooly has conjured an entire civilization out of mud. Through the medium of clay, Gilhooly has materialized a cosmology of amphibious creatures, his all-encompassing "Frog World," which occupied him during much of the 1970s. The son of a veterinarian, Gilhooly earned a degree in marine biology in addition to pursuing studies in anthropology and paleontology. These early interests inform his ceramic works, which he began creating in the 1960s while studying under Robert Arneson (see pl. 1) at the University of California, Davis.

Appropriately enough, Gilhooly's complex frog culture began with the *Creation of Frog Adam* in 1969. Since this act of genesis, Gilhooly has created a panoply of other figures, drawing on religious traditions from Christianity to Hinduism, as well as historical figures, for inspiration. These assorted frog characters are engaged in epic escapades, humorously revealing human foibles and obsessions.

Egyptian culture has proved an especially rich source for Gilhooly's cosmology. Frogs were a symbol of fertility and resurrection in Egyptian religion, given their ability to emerge almost miraculously from the mud. Gilhooly's "Frog Osiris," a central character in his early work, is based on the Egyptian god of the underworld and vegetation. In *Osiris Vegefrogged* (pl. 9) Gilhooly unites the fertile god with his recurring vegetable motif to create a frog-faced heap of produce teeming with fecundity.

9 OSIRIS VEGEFROGGED
1973
EARTHENWARE, GLAZED
HEIGHT 13¾ INCHES (34.9 CM)
PURCHASED WITH THE BLOOMFIELD
MOORE FUND, 1974-79-1

WAYNE HIGBY

As an undergraduate, Wayne Higby took a trip around the world that altered the course of his life. On the island of Crete, he encountered ancient Minoan pots in a museum and his eyes were opened to the potential of ceramic vessels, particularly the deft integration of imagery and form. "On that day I became a potter,"[1] recalls Higby. He has since gone on to explore the metaphorical possibilities of the vessel form.

Higby's formal investigations are tied to his desire to convey landscape in a dynamic fashion. His fascination with mesas and other geographical formations stems from his youth in Colorado, where he rode on horseback through rugged terrain and wide-open spaces. He has also found inspiration in Chinese landscape painting and Islamic pottery. "My sense of self is intertwined with a feeling, even a longing, for space, color, light. Like a Chinese landscape painter, I often seek out empty space," says Higby.[2] His shift from slab-built forms to thrown and altered vessels in the early 1970s was inspired by the rolling hills at New York's Alfred University, where he was teaching. The landscape bowls, for which Higby became famous in the mid-1970s, emerged from an attempt to capture geographical experience in three dimensions. These large bowls are designed to create an interplay between real and depicted space, with the bowl serving as a landscape element in the viewer's own environment.

Higby's landscape sculptures such as *White Granite Bay* (pl. 10) and landscape bowls such as *Frozen Day Mesa* (pl. 11) invite us to reconsider our relationship to the surrounding space. Rather than simply depicting a static scene, Higby creates painted forms that force our attention to glide between actual and illusionistic terrain. His vessels offer a means of vicarious transport, and the multiple, shifting vantage points in his compositions ensure that the viewer's journey is an engaging one.

1. Louise Klemperer, "Wayne Higby," *American Ceramics* 3, no. 4 (1985), pp. 34–35.
2. Robert Turner, *Wayne Higby* (New York: Helen Drutt Gallery, 1990), p. 4.

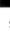

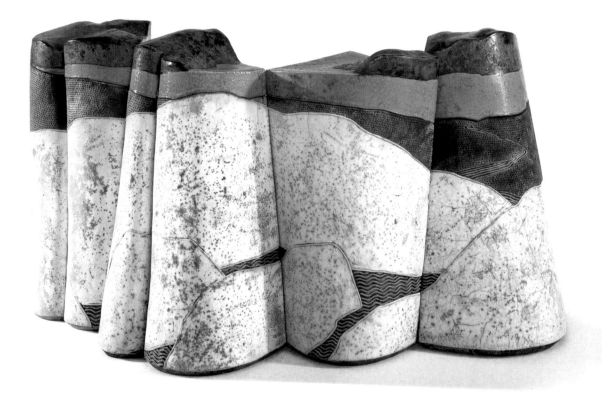

10 WHITE GRANITE BAY

1982

EARTHENWARE, RAKU-FIRED AND GLAZED

HEIGHT APPROXIMATELY 12 INCHES (30.5 CM) EACH

GIFT OF MRS. ROBERT L. McNEIL, JR.

2001-23-1–4

WAYNE HIGBY

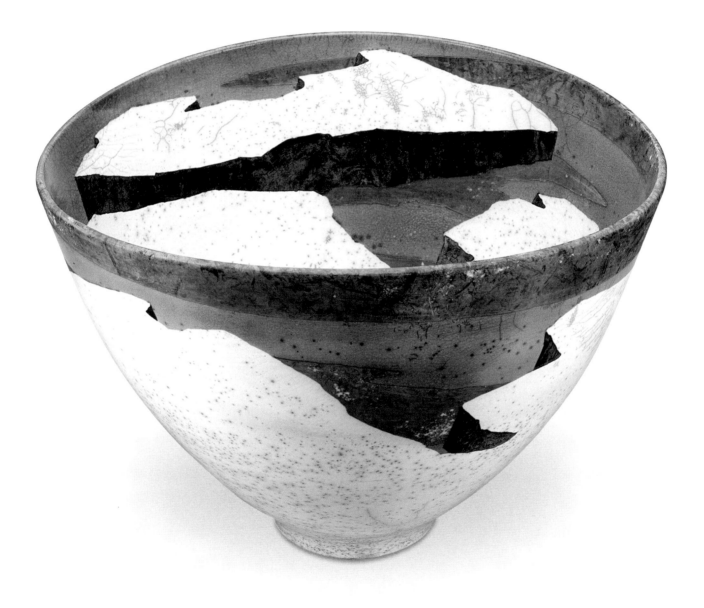

11 FROZEN DAY MESA
1984
EARTHENWARE, RAKU-FIRED AND GLAZED
HEIGHT 12½ INCHES (31.8 CM)
PROMISED GIFT OF HARVEY S. SHIPLEY MILLER
AND J. RANDALL PLUMMER

JUN KANEKO

Trained as a painter in Japan, Jun Kaneko moved to Los Angeles in 1963 and enrolled at the Chouinard Art Institute (now California Institute of the Arts), where he began making ceramic sculpture. His early artistic experience reveals itself in his mature work, which blends painterly surfaces with strong sculptural form.

Kaneko's sensibility is evident in his series of oversized plates and platters. These clay slabs serve as three-dimensional canvases for the artist's formal explorations. Often starkly monochromatic, as in his 1984 *Plate* (pl. 12), Kaneko's circumscribed fields of painterly glaze are closely related to abstract painting.

Kaneko has become best known for his trademark "Dangos," large, swollen shapes that are based on the Japanese steamed dumpling. Inflating the small edible form to monumental proportions, Kaneko has created Dangos more than ten feet high and weighing over five tons. The potency of these convex sculptures is increased through the application of vibrant glazes in striking patterns, from dots to stripes to spirals.

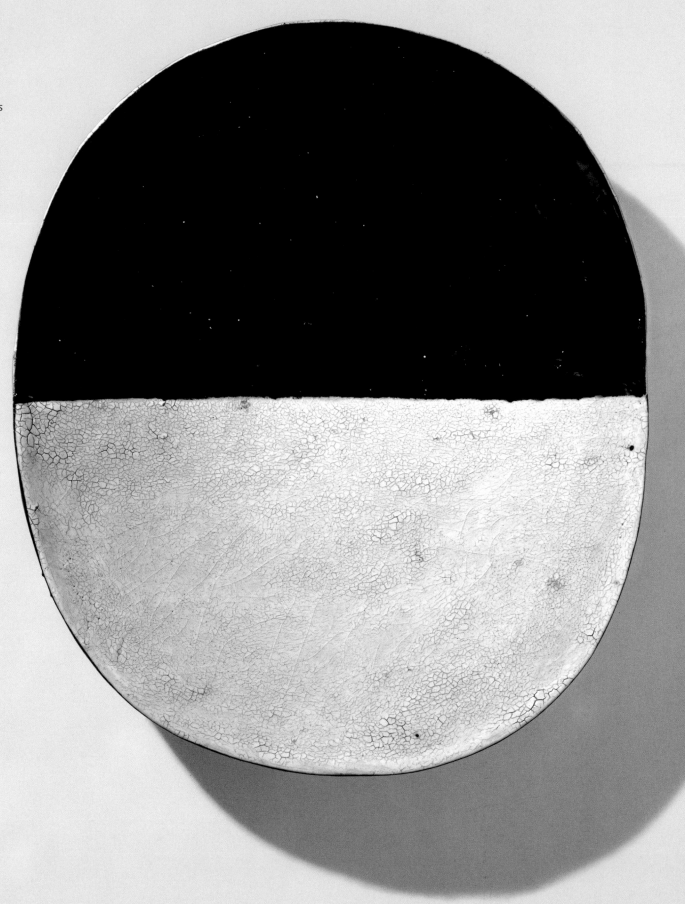

12 PLATE
1984
STONEWARE, GLAZED
WIDTH 20 INCHES (50.8 CM)
GIFT OF MARION BOULTON STROUD
1984-101-1

MICHAEL LUCERO

Michael Lucero's colorful and often monumental ceramic works are a hybrid of painting and sculpture. Born and raised in California, Lucero in many ways has continued the sculptural explorations and provocative subject matter of the groundbreaking generation of West Coast ceramists that included Robert Arneson (see pl. 1), Viola Frey (see pl. 8), and Richard Shaw (see pl. 22).

Lucero began working with clay as an undergraduate painting major at Humboldt State University in Arcata, California, in the mid-1970s. Upon graduation, he entered the M.F.A. program in ceramics at the University of Washington in Seattle, where he studied under Howard Kottler and Patty Warashina. Since 1978, he has lived and worked in New York, but much of the subject matter of his art remains grounded in the physical and mental landscape of his childhood in the West, and particularly in New Mexico, where his family has deep roots. The artist spent summers as a boy visiting his grandparents in Santa Fe and now maintains a studio there. The Southwest landscape and fauna, as well as the region's indigenous traditions, have emerged in his work, most notably in the "Earth Images" and "Dreamer" series of the mid-1980s.

Lucero's "Dreamer" series conjoins personal narrative with modernist sculpture and allusions to ancient art. Many of these oversized heads lie horizontally, as if toppled from giant statuary. Lucero cites Constantine Brancusi's iconic 1915 sculpture *Sleeping Muse* as the inspiration for this series,[1] but unlike Brancusi's pristine ovoid, Lucero's rugged heads are awash in painted scenery. The peaceful countenance of Lucero's dreamers is often at odds with the disturbing content of the painted scenes. These psychic landscapes, with the characteristically disjunctive imagery of dreams, tap into the artist's own childhood nightmares of falling into the craggy New Mexican landscape.[2] *Rock Garden Dreamer* (pl. 13), for instance, features crags and volcanoes, as well as a headless, limbless torso. As in many of the "Dreamers," the artist also pays homage to the stepped structures of the region's Pueblo architecture.

1. Mark Richard Leach and Barbara J. Bloemink, *Michael Lucero: Sculpture 1976–1995* (New York: Hudson Hills Press, 1996), p. 52.
2. Ibid., p. 53.

13 ROCK GARDEN DREAMER
1984
EARTHENWARE, GLAZED
WIDTH 24 INCHES (61 CM)
GIFT OF CHARLES W. NICHOLS
2001-199-1

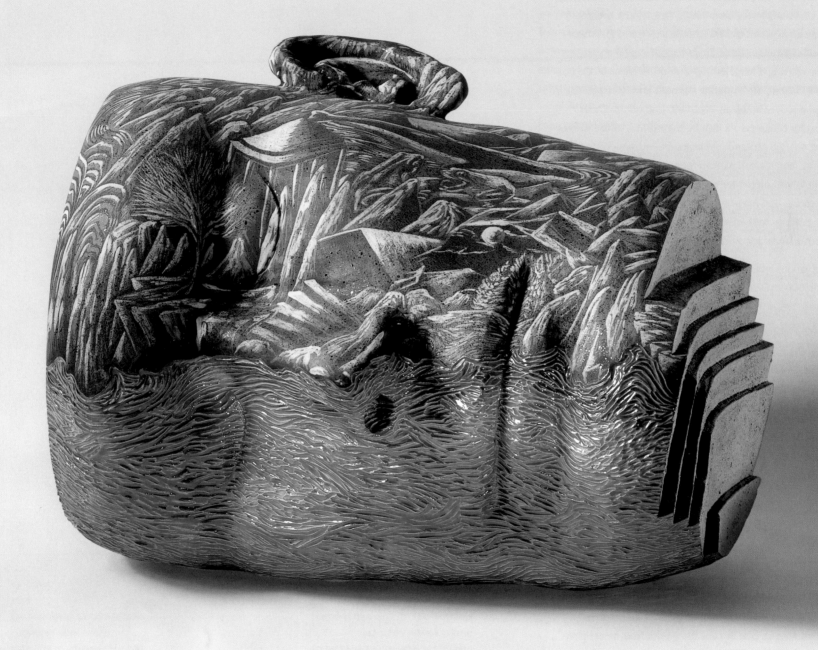

GERTRUD and OTTO NATZLER

16 PLATE
1941
EARTHENWARE, GLAZED (WHITE
ORNAMENTAL GLAZE)
DIAMETER 12 INCHES (30.5 CM)
GIFT OF MRS. HERBERT CAMERON
MORRIS, 1945-68-3

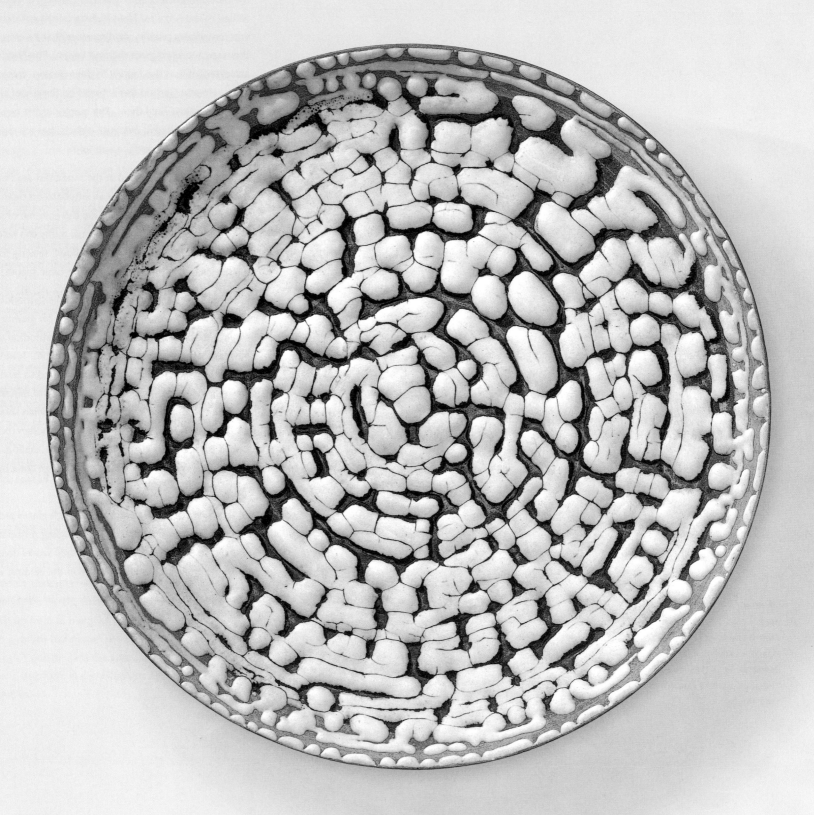

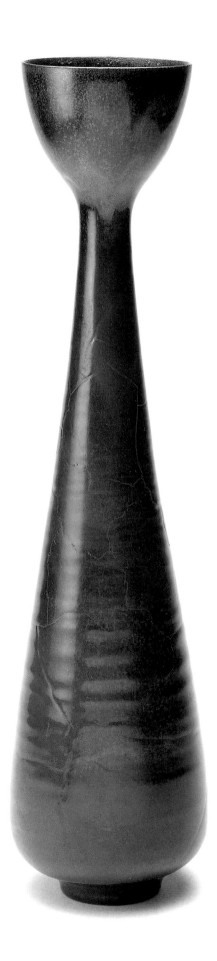

17 BOTTLE

1957

EARTHENWARE, GLAZED (SANG NOCTURNE
REDUCTION GLAZE)

HEIGHT 17⅜ INCHES (44.1 CM)

THE LOUIS E. STERN COLLECTION

1963-181-193

18 VASE

1962

EARTHENWARE, GLAZED (DARK RED GLAZE)

HEIGHT 8½ INCHES (21.6 CM)

GIFT OF THE WOMEN'S COMMITTEE

OF THE PHILADELPHIA MUSEUM OF ART

1985-78-1

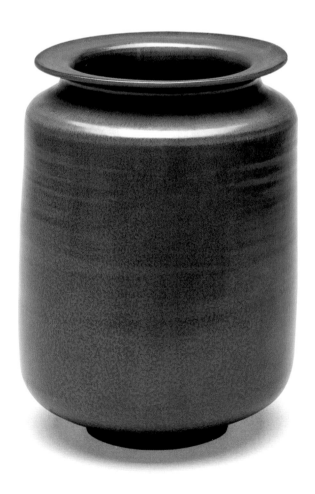

WILLIAM PARRY

William Parry has rightly been called a "master of morph-
ing,"[1] as his ceramic works transform common objects
into unlikely sculptural forms. Parry earned his B.F.A. at the
New York State College of Ceramics at Alfred University
and taught at the Philadelphia Museum School of Art (now
University of the Arts) before returning to Alfred in 1963
as a professor of ceramics and sculpture. While he has
continued to explore various materials—including wood,
leather, bronze, and rubber—clay has become his medium
of choice. The artist has said that he strives to make works
"in which the medium is insistent,"[2] and his handling of clay
demonstrates this by emphasizing the material's origins as a
raw, earthy substance.

While Parry's subjects are often drawn from nature, he
has also metamorphosed everyday manmade objects in
his art, as in *KFS (Knife, Fork, Spoon) II* (pl. 19). He worked
for a tableware manufacturer during his college years, and
his familiarity with the permutations of culinary utensils
emerges in this trio. In his oversized rendition of these
common implements, their delicate forms become coarse,
almost neolithic tools with an assertive, albeit amusing,
sculptural presence. Turning flatware into stoneware, fine
cutlery into club-like objects, Parry reveals his penchant
for transforming the mundane into the remarkable.

1. Richard Zakin, "William Parry: The Medium Is Insistent," *Ceramics
 Monthly* (March 1998), p. 65.
2. Ibid.

19 KFS (KNIFE, FORK, SPOON) II
c. 1982
STONEWARE WITH APPLIED COLOR
LENGTH (KNIFE) 22 INCHES (55.9 CM);
(FORK) 24 INCHES (61 CM); (SPOON)
24 INCHES (61 CM)
GIFT OF THE ARTIST, 1995-77-1A–C

KENNETH PRICE

After receiving his B.F.A. from the University of Southern California in 1956, Kenneth Price studied with Peter Voulkos (see pl. 32) at the Los Angeles County Art Institute (now Otis Art Institute), where he became involved in the so-called Abstract Expressionist clay movement that was attempting to usher ceramics away from utility and toward more expressive, sculptural ends. Associated with the "finish fetish" branch of this group, which also included Ron Nagle (see pl. 14), Price went on to create boldly polychromatic works, often with pristine surfaces. Eschewing the lingering truth-to-materials doctrine, he set out to explore the endless possibilities of color and form, without regard for clay's natural properties. Although Price has retained the vessel format in many of his works, his creative pursuits have led him to emphasize sculptural form above utility.

His first major body of work, created in the 1960s, was a series of egg-shaped sculptures. With protuberances and emerging worm-like forms, these works convey an unsettling, albeit seductive, animism. Price's vibrant palette already was in evidence in these early painted ceramics. From the biomorphic ovoids, Price shifted to a deconstructive series of cups, with equally finessed surfaces and unorthodox colors. Geometry ruled works such as his 1981 *Untitled* (pl. 20), which explores various permutations of angles and arcs.

By the late 1970s, Price shunned all reference to function and began making boulder-like sculptures with a complex typography. A mix of geometry and geology, these sculptures are given layers of mottled and abraded paint. The hulking masses are cleanly sliced to reveal brightly colored planes, with occasional black holes that provide a disconcerting sense of entry into the form, as in *Grauman's* (pl. 21). In his most recent works, Price continues his formal explorations with bulging and undulating anthropomorphic clay sculptures.

20 UNTITLED
1981
PORCELAIN, GLAZED AND PAINTED
HEIGHT 10 INCHES (25.4 CM)
GIFT OF THE WOMEN'S COMMITTEE OF
THE PHILADELPHIA MUSEUM OF ART
1981-38-3

21 GRAUMAN'S

1988

PORCELAIN, GLAZED AND PAINTED

HEIGHT 9 INCHES (22.9 CM)

GIFT OF THE WOMEN'S COMMITTEE OF

THE PHILADELPHIA MUSEUM OF ART

1989-20-3

RICHARD SHAW

As the son of a Disney writer and cartoonist, Richard Shaw seemed destined to create fanciful and engaging works.[1] Originally intent on being a painter, Shaw shifted his focus to ceramics in the mid-1960s when he studied at the University of California, Davis, with Robert Arneson (see pl. 1), Ron Nagle (see pl. 14), and other prominent California ceramic artists. Shaw has since mastered the art of trompe l'oeil ceramics, creating confoundingly realistic still lifes and assembled figures. Working in a ceramic tradition that dates back to predynastic Egypt, Shaw produces virtuoso work that is motivated by a desire to transform the commonplace into a source of wonder. "There is something I like about artists spending all that time and talent on the mundane," says Shaw. "It seems so absurd, nuts and wonderful . . . and yet a way to make poetry."[2]

Shaw's super-realist work rests on his skillful handling of slip-cast porcelain, a process he perfected while collaborating with the sculptor Robert Hudson in the early 1970s. While slip casting allows him to capture an accurate likeness of form, the realistic surfaces of his ceramics are realized through decal transfers that burn into the clay when it is fired, a process Shaw received a National Endowment for the Arts grant to explore. With these two techniques, Shaw is equipped to replicate any imaginable object, from bones to books.

Shaw's still-life compositions often mix organic and inorganic items, arranged like a casual display of modern-day specimens. His series of walking figures, including *Walking Skeleton* (pl. 22), are built from cast branches, bottles, cards, and other sundry materials — "taking the still lifes and bringing them up into these people,"[3] as Shaw describes it.

1. Bill Berkson, "Shaw Business," *American Craft* 56, no. 5 (October–November 1996), p. 79.
2. Joseph Pugliese, *Richard Shaw: Illusionism in Clay* (San Francisco: Braunstein Gallery, 1985), p. iii.
3. Berkson, "Shaw Business," p. 81.

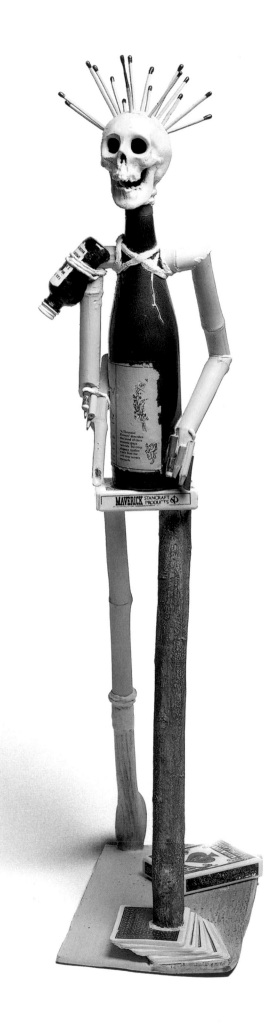

22 WALKING SKELETON
1980
PORCELAIN, GLAZED
HEIGHT 31½ INCHES (80 CM)
GIFT OF THE WOMEN'S COMMITTEE OF
THE PHILADELPHIA MUSEUM OF ART
1981-38-4

PAUL SOLDNER

Best known for introducing the raku process to the United States, where it was virtually unknown, Paul Soldner has contributed extensively to the field of ceramics. While studying with Peter Voulkos (see pl. 32) in the mid-1950s at the newly formed ceramics department at Los Angeles County Art Institute (now Otis Art Institute), Soldner experimented with a method he called "extended throwing." By adding clay coils to the top of thrown pots, he could create vessels more than seven feet high. Soldner wrote his master's thesis on the subject and is credited with inspiring Voulkos's later series of stacked clay pots.

In 1960, Soldner began exploring the raku technique, a method of firing developed in sixteenth-century Japan that allows for variegated surfaces and softly modulated color effects. More than just a technique for Soldner, raku is a creative philosophy that includes an appreciation for natural processes and chance occurrences. According to Soldner, raku emphasizes "the beauty of the accidental and sponta-neous, asymmetry, value of, and appreciation for, nature undominated or controlled by man."[1] Soldner was influen-tial in disseminating both the technical and philosophical aspects of raku, encouraging artists to accept accident and improvisation and to respect the natural properties of clay. As seen in his 1972 *Vase* (pl. 23), Soldner's so-called American raku went beyond the monochromatic and unadorned surfaces of traditional Japanese raku ware, as he embellished his pots with imagery, patterns, and incised markings.

1. Peter Lane, *Studio Ceramics* (Radnor, PA: Chilton Book Company, 1983), p. 223.

23 VASE
1972
EARTHENWARE, RAKU-FIRED
HEIGHT 18 INCHES (45.7 CM)
GIFT OF J. WELLES AND
HANNAH L. HENDERSON
1996-172-1

RUDOLF STAFFEL

Rudolf Staffel has been called a "watercolorist in clay," and the translucency of his porcelain vessels rivals the effects of this delicate medium.[1] Indeed, Staffel began his artistic career as a painter. Even as a teenager he was enamored of the loose, wet brushwork of Chinese and Japanese Zen paintings. He studied painting, drawing, and design at the Art Institute of Chicago in the early 1930s, and later studied in New York with the influential German-born Abstract Expressionist painter Hans Hofmann, whose push-pull theory of compositional dynamics impacted Staffel's own handling of clay. During a stay in Mexico, where he went to study glassblowing, Staffel encountered pre-Columbian ceramics and was inspired to begin working with clay. His early stoneware works were more figurative, and sometimes overtly political, as in *Head* (pl. 24), Staffel's reaction to the trials of nine African American teens accused of rape in Scottsboro, Alabama, in 1931.

Starting in the late 1950s Staffel worked solely in porcelain, which allows for the same lucidity as glass or paint. The only ingredient that Staffel's porcelain vessels are designed to hold is light. As is most evident in his "Light Gatherer" series (pls. 25–27), capturing light was his ongoing passion. "Even when I was a painter, I was always interested in light," he said. "Something about light coming through glass, wax, or snow. I wanted to achieve a passage of light."[2]

Staffel alternated between thrown and hand-built forms, in both cases striving for freshness of execution. His handling of porcelain defied the material's usual associations with fragility and preciousness. While taking advantage of the clay's crystalline luminosity, he had no qualms about manipulating the material in unprecedented ways; piercing, stretching, folding, and engraving were all enlisted to aid in the transmission of light. His hand-built works, in particular, reveal his improvisation in constructing the vessel, as he pinched, pulled, layered, and patched up tears with clay swatches. Staffel's spontaneous process harked back to his early inspirations of Chinese brush painting and Abstract Expressionism.

1. *Rudolf Staffel: Searching for Light; Ceramics, 1936–1996*, exh. cat. (Helsinki: Museum of Applied Arts, 1996), p. 9.
2. Paula and Robert Winokur, "The Light of Rudolf Staffel," *Craft Horizons* 37, no. 2 (April 1977), p. 25.

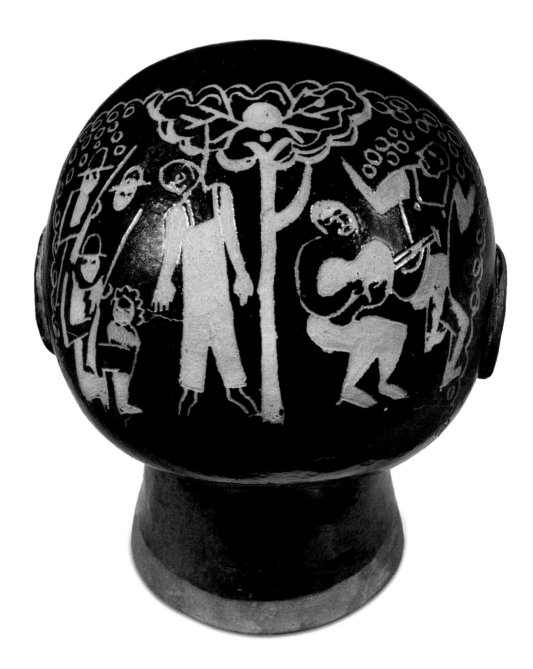

REVERSE

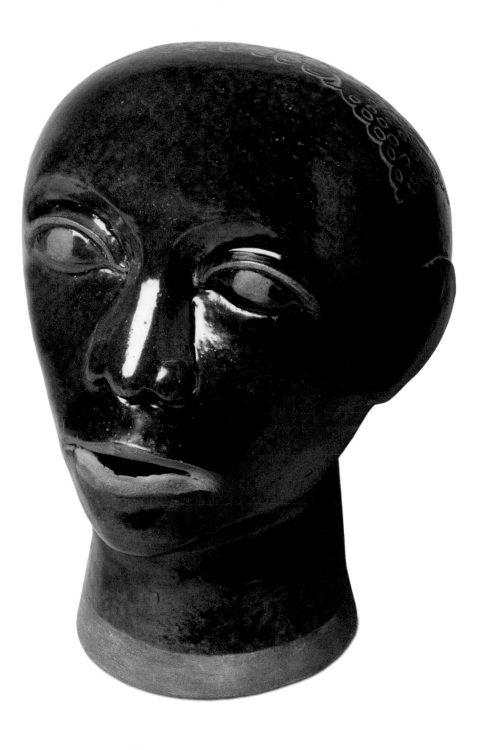

24 HEAD
1938
STONEWARE, GLAZED
HEIGHT 8⅜ INCHES (21.3 CM)
PURCHASED WITH FUNDS CONTRIBUTED BY
DANIEL W. DIETRICH, HENRY S. McNEIL, JR.,
BETTY GOTTLIEB, FRANCES AND BAYARD
STOREY, ROBERT TOOEY AND VICENTE LIM,
JUNE AND PERRY OTTENBERG, AND THE
ACORN CLUB, AND GIFT OF HELEN WILLIAMS
DRUTT ENGLISH IN HONOR OF THE ARTIST
2001-109-1

RUDOLF STAFFEL

25 BOWL

1969

PORCELAIN, UNGLAZED

DIAMETER 9½ INCHES (24.1 CM)

GIFT OF THE PHILADELPHIA CHAPTER,

NATIONAL HOME FASHIONS LEAGUE, INC.

1970-86-3

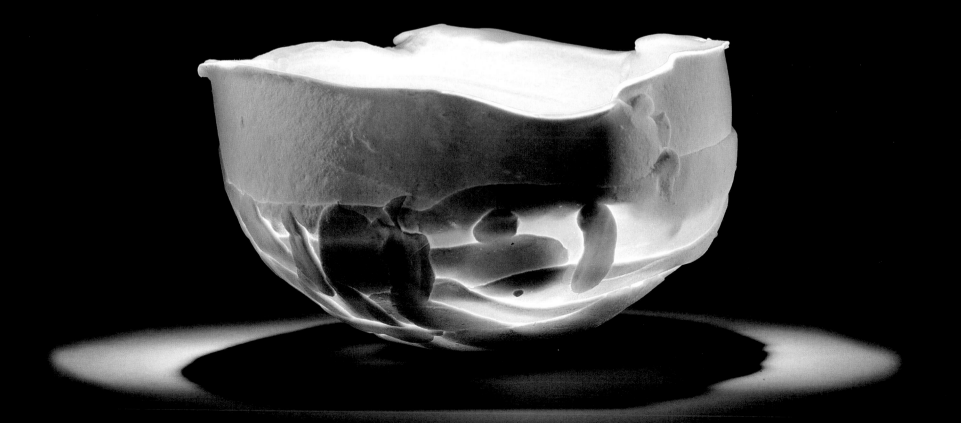

26 LIGHT GATHERER

1981

PORCELAIN, PARTIALLY GLAZED

HEIGHT 6¼ INCHES (15.9 CM)

PURCHASED WITH FUNDS CONTRIBUTED

BY THE WOMEN'S COMMITTEE OF THE

PHILADELPHIA MUSEUM OF ART

1997-65-1

27 VASE

1973

PORCELAIN, UNGLAZED, WASHED WITH

COPPER SALTS

HEIGHT 8⅞ INCHES (22.5 CM)

GIFT OF DR. AND MRS. PERRY OTTENBERG

1991-161-3

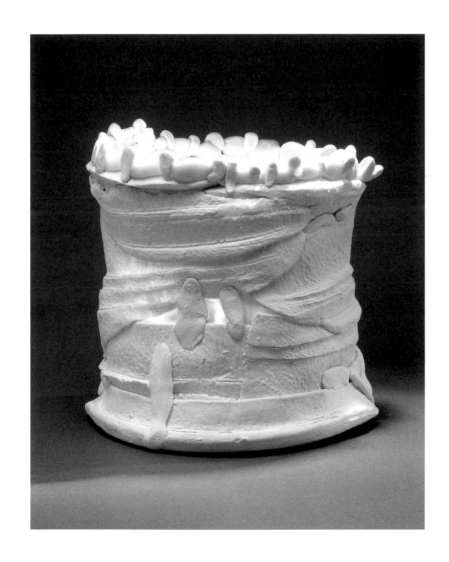

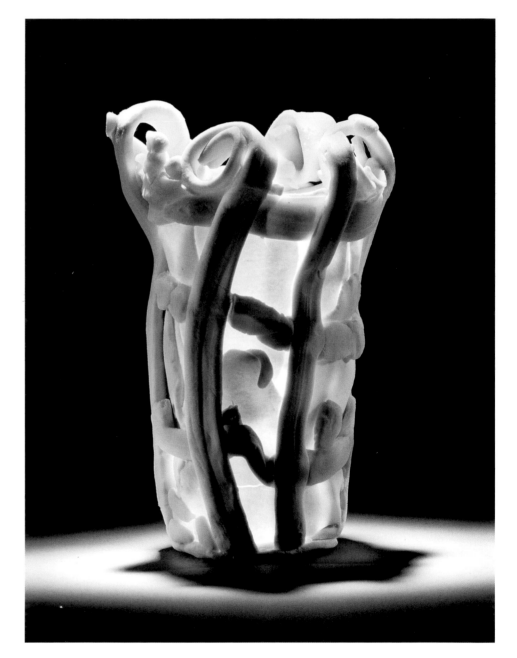

TOSHIKO TAKAEZU

Toshiko Takaezu began her ceramic studies at the University of Hawaii and later studied under Finnish-born potter Maija Grotell at the Cranbrook Academy of Art in Bloomfield Hills, Michigan. In 1955, shortly after her graduation, Takaezu traveled to her ancestral home of Japan, where she spent eight months studying Zen Buddhism and visiting folk potters, including Shoji Hamada. This encounter with Eastern philosophy and aesthetics would help shape Takaezu's later works.

Like many ceramists, Takaezu began by making functional vessels such as bottles and teapots. Her creative explorations led her to focus on the opening of the vessel. She gradually decreased the hole in her forms until, in the late 1950s, she arrived at the closed pots for which she is best known. Although the interiors of these pots are inaccessible to our gaze, the closed forms still draw the viewer in through richly nuanced glaze treatment and inviting torso-like contours.

Ranging from a few inches to several feet high, as in the nearly four-foot-tall *Form* (pl. 28), Takaezu's closed pieces also contain an engaging secret. Before closing and firing her pots, the artist inserts small clay beads that become sealed inside the form, as in a rattle, to stimulate the beholder's ears and imagination. The unseen becomes just as powerful as the seen in Takaezu's works, which function not as containers but rather as instruments of delight. Her exploration of the auditory dimension has also led to a series of cast-iron bells that openly proffer multisensory pleasure. As Takaezu has stated, "There is sound in form, and in a way sound and form are alike."[1]

1. Joseph Hurley, "Toshiko Takaezu: Ceramics of Serenity," *American Craft* 39, no. 5 (October–November 1979).

28 FORM
1990
STONEWARE, GLAZED
HEIGHT 45 INCHES (114.3 CM)
GIFT OF THE WOMEN'S COMMITTEE OF
THE PHILADELPHIA MUSEUM OF ART
1992-109-3

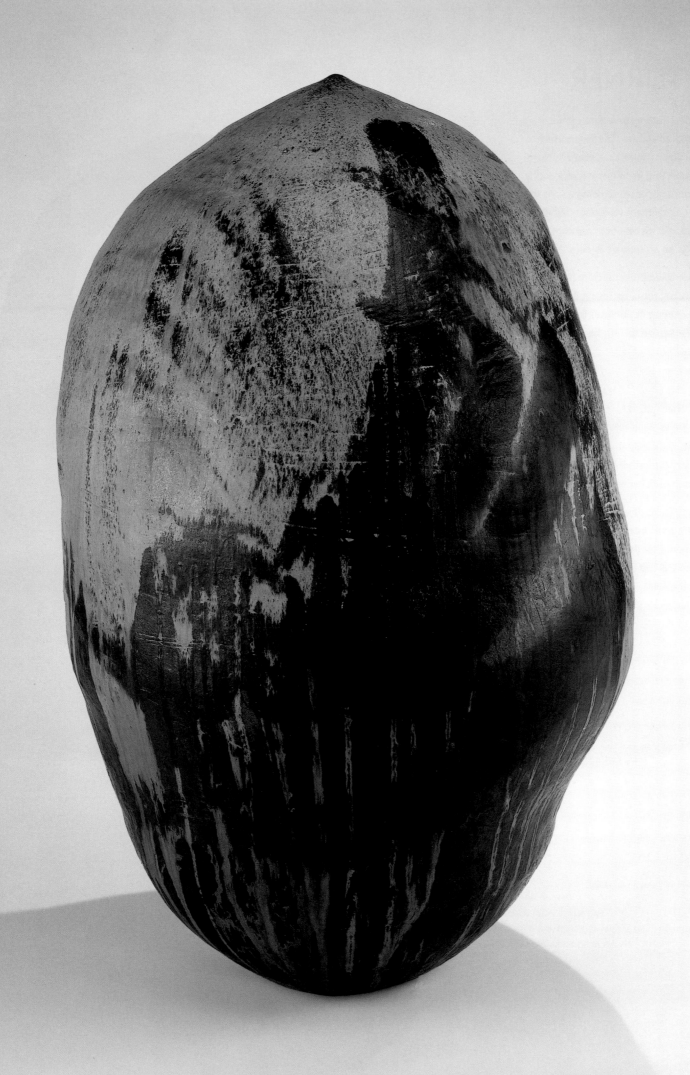

PETER VOULKOS

As the prime force behind the so-called Abstract Expressionist clay movement of the 1950s, Peter Voulkos helped to establish ceramics as a viable expressive and sculptural medium. Like New York's Abstract Expressionist painters, these ceramists created work that was marked by improvisation, intensity, and monumentality. Influential as both an artist and a teacher, Voulkos served as a conduit for ideas that would liberate the medium from its traditional forms and functions.

Voulkos entered art school on the G.I. Bill in 1946 and eventually shifted his focus from painting to pottery. His facility was soon apparent, and in 1949 he won the prestigious U.S. Potter's Association Prize. After earning his M.F.A. at the California College of Arts and Crafts in Oakland in 1952, he became the first resident potter of the newly created Archie Bray Foundation in Helena, Montana. There he met potters Bernard Leach, Shoji Hamada, and Soetsu Yanagi, who introduced him to Japanese folk pottery and Asian aesthetic principles.

In 1953, Voulkos was invited to teach at the experimental Black Mountain College in North Carolina, where he met Josef Albers, John Cage, Merce Cunningham, Buckminster Fuller, and painters from the Abstract Expressionist school, including Willem de Kooning and Jack Tworkov. This encounter with the avant-garde catalyzed Voulkos, who approached his ceramics with a new vigor and soon began making vessels of unprecedented scale and vitality. He brought this sense of excitement to the Los Angeles County Art Institute (now Otis Art Institute) in 1954, when he was appointed chair of the new ceramics department. For five years at the Institute—where his students included Paul Soldner (see pl. 23) and Kenneth Price (see pls. 20, 21)—and from 1959 to 1989 at the University of California, Berkeley, Voulkos ignited new possibilities within the ceramics field.

Voulkos's dramatic and rugged works emerged from a mixture of Asian aesthetic philosophy and Abstract Expressionist principles, combined with the improvisational nature of jazz, which deeply interested the artist. From Japanese ceramics he acquired an appreciation for imperfection and the medium's natural properties, an attitude that was intensified by Abstract Expressionism's emphasis on process, risk, and embodied energy. Voulkos's pots are like action paintings in three dimensions, with the clay's responsive surface recording every gesture of the creative process, forming a topography of gouges, carvings, punctures, and tears. He combined wheel-thrown forms and slabs to create his nonfunctional vessels, which he then modified to increase sculptural power and surface dynamics. His stacked pots can exceed four feet in height, confronting the viewer with their presence and raw materiality.

In 1961, after seven years of testing the limits of ceramic form, Voulkos virtually abandoned the medium to focus on bronze sculpture. When he resumed intensive work in clay in the early 1970s, he continued his explorations of the medium's formal and expressive potential, often producing works with greatly increased scale and heft, such as the nearly three-foot-high 1977 *Vase* (pl. 32).

32 VASE

1977

STONEWARE, UNGLAZED

HEIGHT 34 INCHES (86.4 CM)

GIFT OF THE WOMEN'S COMMITTEE OF

THE PHILADELPHIA MUSEUM OF ART

1989-20-4

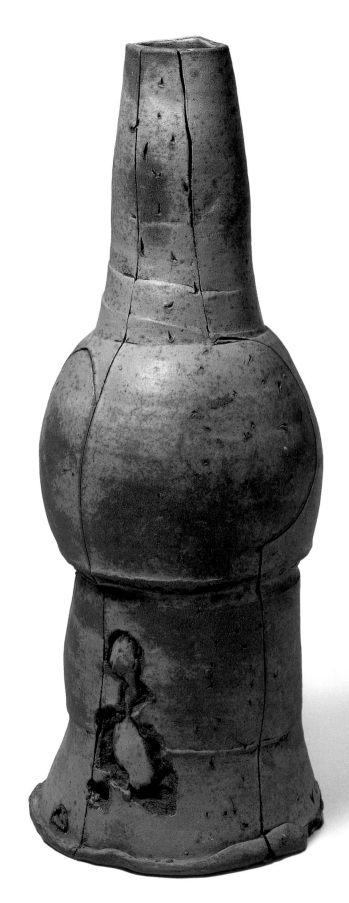

ROBERT WINOKUR

After studying with Rudolf Staffel (see pls. 24–27) at the Tyler School of Art in Philadelphia, Robert Winokur went on to the New York State College of Ceramics at Alfred, where he earned his M.F.A. in 1958. "In the Alfred tradition, I became a pseudo-Sung [dynasty] potter,"[1] recalls Winokur, and his early works partake of the unembellished character of that period's pottery. In the mid-1960s Winokur and his wife, ceramist Paula Winokur, supported themselves through their production ware. In 1966, he returned to Philadelphia to assume a teaching position at Tyler.

Winokur has since decreased his output of utilitarian ware, although he continues to work in the vessel format. According to the artist, "Of all things my least concern is with function or utility. My primary concern is with the abstract elements of edge, line, volume, shape, space, color, texture and all of those things inherent in well-defined form."[2]

Winokur's overriding concern with the formal properties of his works has led to experiments in structure and glazes. Using traditional vessel shapes—pitchers, cookie jars, jugs—as a point of departure, Winokur's hand-built pots assume unexpected proportions and anatomy. His assembled stoneware vessels share structural properties with furniture and architecture, and the surfaces are often incised or developed in shallow relief. Winokur's mastery of the salt-glaze technique (pl. 34) results in dramatic abstract passages that play off of the sculptural shapes.

1. Charlotte Sewalt, "An Interview with Robert Winokur," *Ceramics Monthly* (September 1977), p. 31.
2. "News and Retrospect," *Ceramics Monthly* (March 1979), pp. 91, 95.

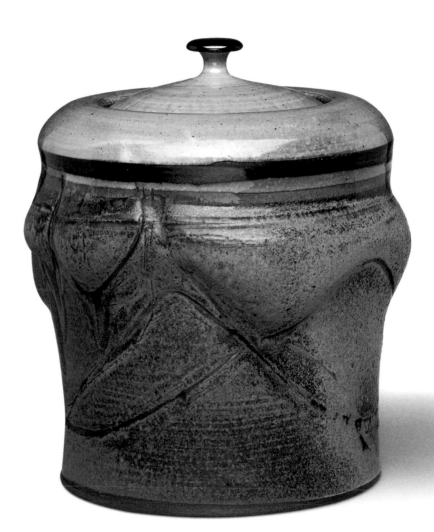

33 COOKIE JAR WITH LID
1972
STONEWARE, GLAZED
HEIGHT 9½ INCHES (24.1 CM)
GIFT OF RUDOLF H. STAFFEL
1973-102-1A, B

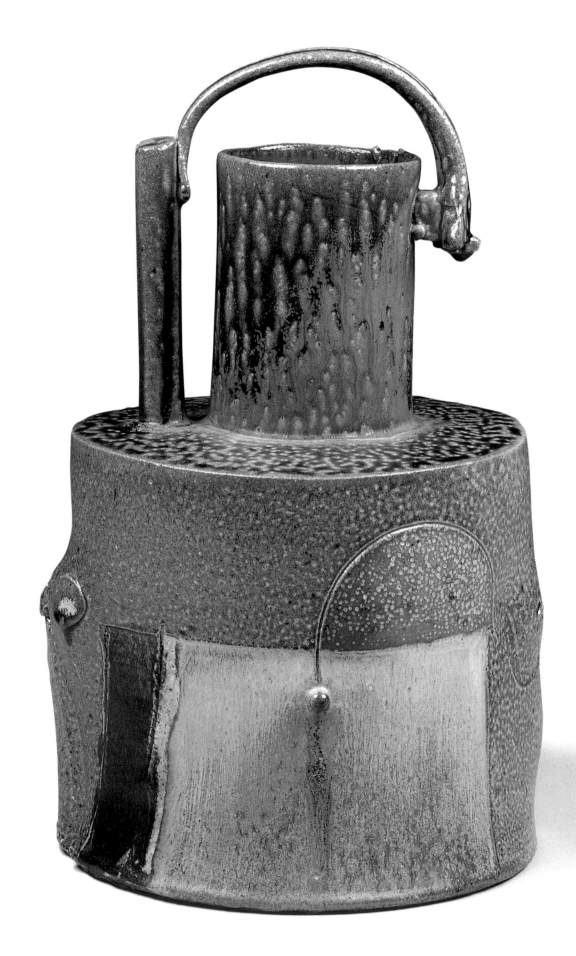

34 JAR WITH HANDLE
1975
STONEWARE, SALT-GLAZED
HEIGHT 16¾ INCHES (42.5 CM)
PURCHASED BY THE ELIZABETH
WANDELL SMITH FUND
1982-69-1

BEATRICE WOOD

Beatrice Wood did not come to ceramics until she was in her forties, following an adventurous early life. While still in her teens Wood went to Paris to pursue studies in art. She eventually found a career on the stage and moved to New York, where she befriended Marcel Duchamp and became active in the circle of Dada artists that included Man Ray and Francis Picabia. In the spirit of Dada, Wood's involvement with ceramics grew out of a chance encounter. Coming across some Persian luster plates in an Amsterdam antique store in 1930, Wood bought the set with the intent of making a matching teapot upon her return to Los Angeles, where she had recently moved. Her determination to master the luster glaze led her to study pottery with Glen Lukens at the University of Southern California, and later with Gertrud and Otto Natzler (see pls. 15–18).

Wood's pursuit of lustrous effects continued unabated during her more than five decades of work in ceramics. She became a forerunner in the use of luster glazes in contemporary ceramics, borrowing from a technique used in Egypt and Persia more than a thousand years ago. With the colorful iridescence of a fiery opal, peacock feather, or beetle's wing, her luster glazes vie with nature's own opulence. These rich glazes adorn forms that are variations on standard historical types—bowls (pl. 35), goblets, vases, teapots, and chalices (pl. 36)—refashioned by Wood into boldly contoured vessels.

In addition to her vessels, Wood also created an ongoing series of figurative sculptures, often with autobiographical content. These "sophisticated primitives,"[1] as she called them, are intentionally naïve in their execution. "They are completely unschooled, unlearned," stated Wood. "I could learn to do slick figures, but that would be too easy."[2] As a long-time collector of folk art—especially from India, where she frequently traveled—Wood maintained a figurative aesthetic that preserved the freshness and playful forms of an untrained artisan. In *Clytemnestra and Iphigenia* (pl. 37), Wood displays open disregard for realistic proportion and color, presenting striped blue felines with human visages. This work also reveals an element of autobiography: the cats, a common subject for Wood, are thought to represent Wood and her mother in the guise of tragic Greek characters.

1. Grace Glueck, "Dada to Pots of Gold: At 104, the View Back Is a Long One," *New York Times* (March 7, 1997).
2. Francis Naumann, *Intimate Appeal: The Figurative Art of Beatrice Wood* (Oakland, CA: Oakland Museum, 1990), p. 34.

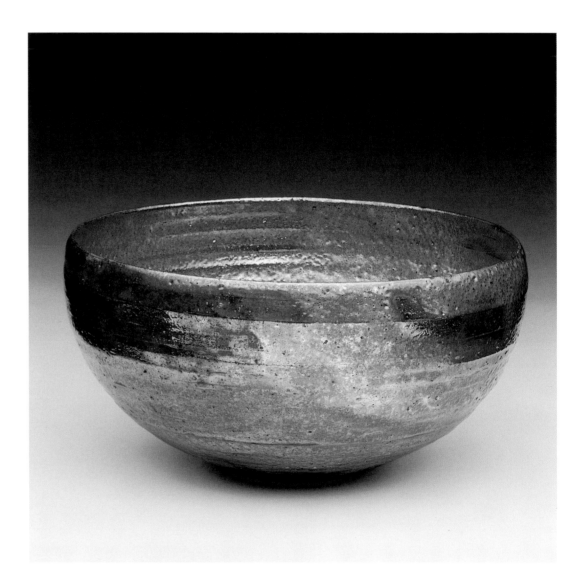

35 BOWL
1948–50
EARTHENWARE, LUSTER-GLAZED
DIAMETER 8½ INCHES (21.6 CM)
GIFT OF THE WOMEN'S COMMITTEE OF
THE PHILADELPHIA MUSEUM OF ART
1984-24-4

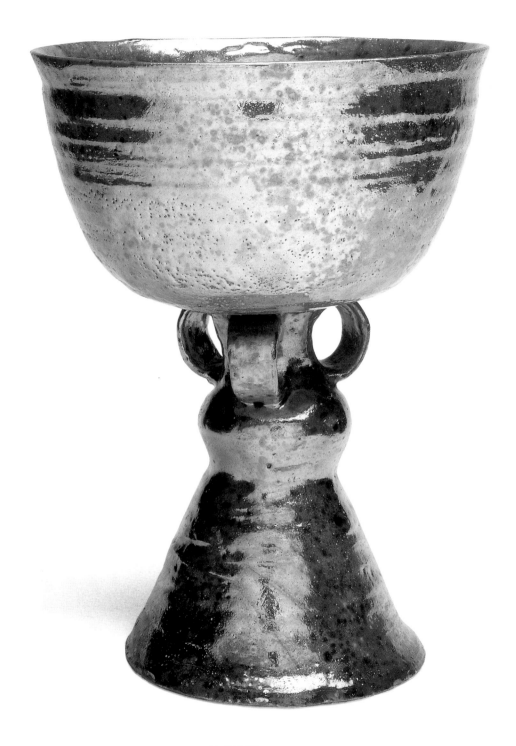

36 CHALICE
EARTHENWARE, LUSTER-GLAZED
HEIGHT 12 INCHES (30.5 CM)
GIFT OF MRS. ROBERT L. McNEIL, JR.
1992-18-2

BEATRICE WOOD

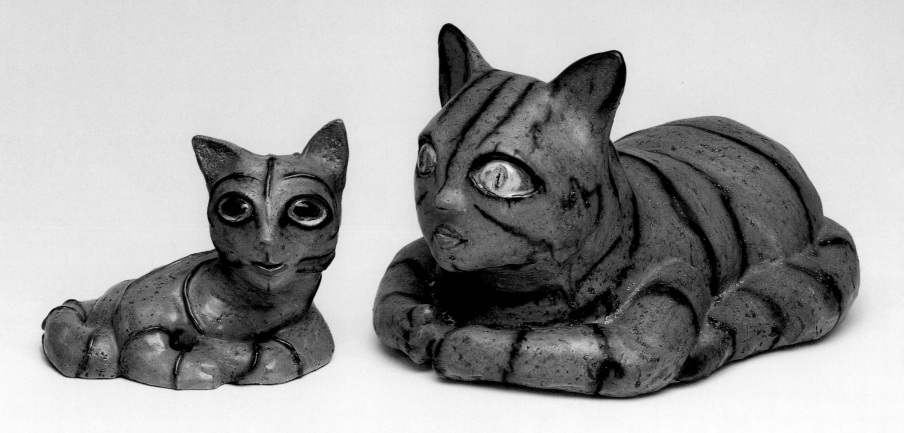

37 CLYTEMNESTRA AND IPHIGENIA (TWO CATS)
c. 1950
EARTHENWARE, GLAZED
HEIGHT (CLYTEMNESTRA) 10 INCHES (25.4 CM);
(IPHIGENIA) 7¾ INCHES (19.7 CM)
GIFT OF THE ARTIST, 1994-101-1, 2

BETTY WOODMAN

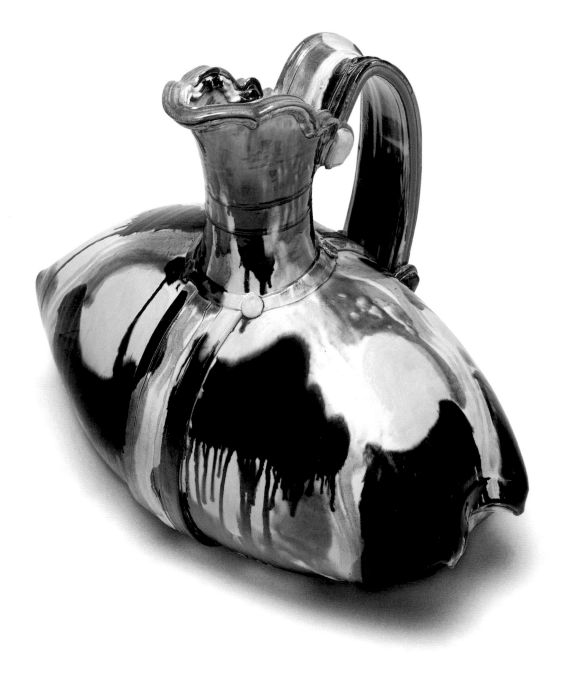

Betty Woodman's works are informed by an extensive knowledge of ceramic history, yet they are unprecedented in their playful complexity. "I try to make art which appreciates the richness of ceramic history but does not try to imitate it,"[1] Woodman has said, and she takes great liberties with earlier prototypes, freely revising and exaggerating her historical models. The result is some of the most daring and exciting work currently being done in ceramics.

Woodman spends summers at her Italian studio, and Mediterranean traditions are especially prevalent in her work. Her historical borrowings—which also include Persian, Chinese, Japanese, and Mexican examples—are just the starting point for her ceramic mutations. The artist's trademark "Pillow Pitchers" (pl. 38) are a case in point. Based on an ancient pneumatic Etruscan pitcher type, Woodman's version is enlarged, embellished, and given an expressionistic glazing in a Tang dynasty palette.

The vitality of Woodman's ceramics derives in part from her playful manipulation of the pot's anatomy, in which lips, shoulders, necks, and handles are all stretched into new positions. She goes beyond distorting the vessel to deconstructing it, cutting and reassembling her thrown forms into multipart compositions, sometimes comprising an entire wall. Planes and volumes are jostled together like puzzle pieces that don't always cohere.

Woodman's energetic glaze treatment further intensifies the play of forms. She creates tension between two and three dimensions, surface and form, with painterly effects often contradicting the contours of the vessel upon which they rest. "I use color to enrich, to counteract, to get the viewer to examine the form,"[2] says Woodman. Her lively glazes—often completely different on the front and back, as in *Spring Outing* (pl. 39)—demand that the forms be circumnavigated, like paintings in the round.

1. Margaret Skove, *Betty Woodman: Between Sculpture and Painting; Recent Work,* exh. cat. (Fort Dodge, IA: Blanden Memorial Art Museum, 1999).
2. Linda Schmidt, "Beyond the Boundaries of History and Form," *American Ceramics* 7, no. 3 (1989), p. 23.

38 PERSIAN SILK PILLOW PITCHER
1982
EARTHENWARE, GLAZED
HEIGHT 19 INCHES (48.3 CM)
GIFT OF MARION BOULTON STROUD
1988-90-1

CERAMICS

73

BETTY WOODMAN

39 SPRING OUTING (TWO VIEWS)
2000
EARTHENWARE, GLAZED, WITH EPOXY
RESIN, LACQUER, AND PAINT
HEIGHT APPROXIMATELY 38 INCHES
(96.5 CM) EACH
GIFT OF THE WOMEN'S COMMITTEE OF
THE PHILADELPHIA MUSEUM OF ART
2001-16-1A–C

Thomas Stearns
Lenore Tawney
Evelyn Svec Ward
Claire Zeisler

FIBER

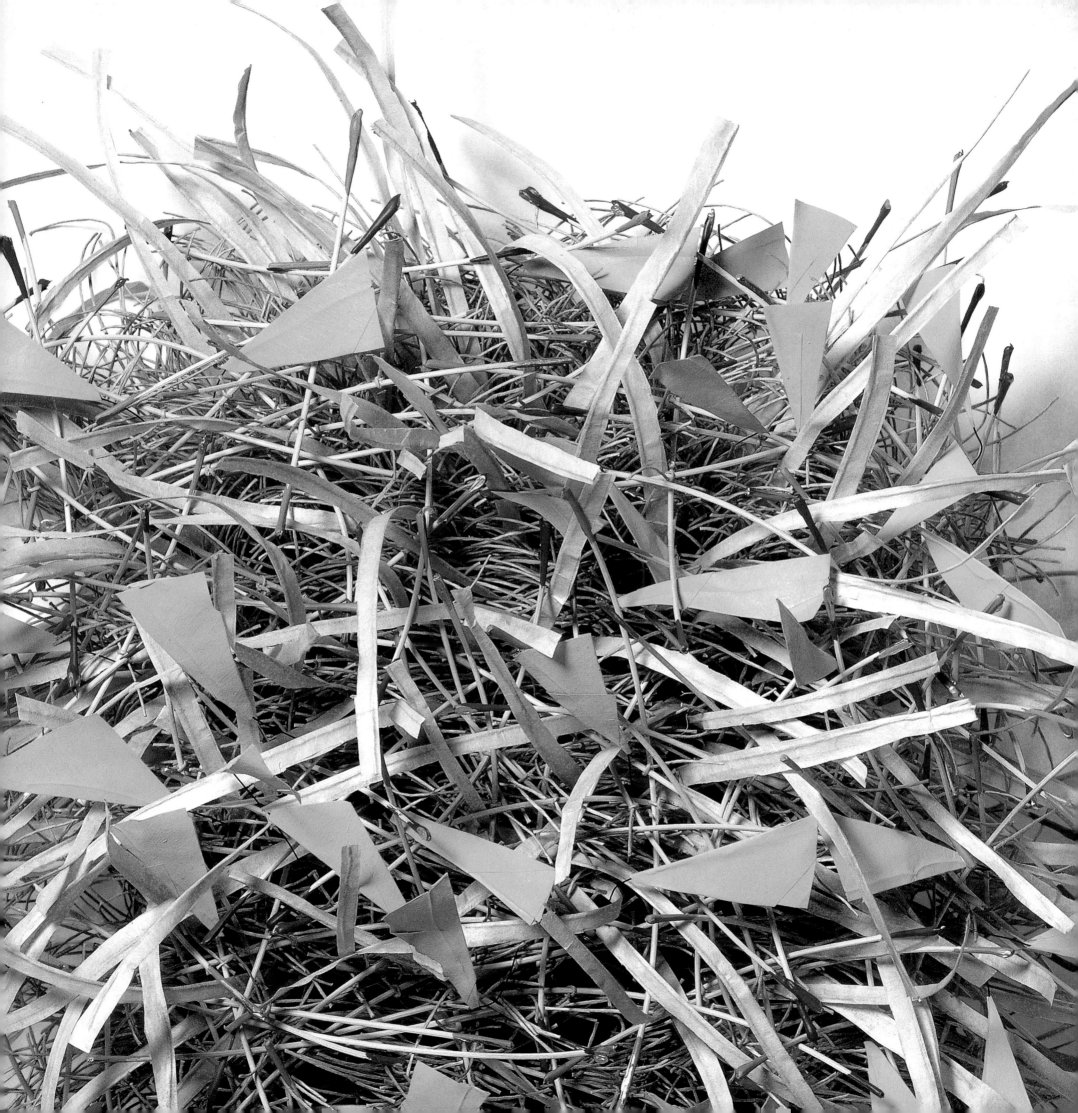

SHEILA HICKS

Sheila Hicks was one of the seminal figures, along with
Lenore Tawney (see pl. 55) and Claire Zeisler (see pl. 57),
of the so-called fiber revolution of the 1950s and 1960s.
Hicks came to textiles by way of painting, which she
studied under Josef Albers at Yale University in the late
1950s. She began weaving while still at Yale and was
further inspired to pursue this medium by her travels to
South America on a Fulbright Fellowship. She continues
to travel broadly and has lived in Chile, Mexico, England,
and France, where she has maintained a studio since 1964.
Her expertise as a textile artist has also served as a point
of entry into other cultures. In the late 1960s and early
1970s, she advised weavers in India on developing
marketable designs, organized weaving workshops in Chile,
and served as a consultant to the Moroccan rug industry,
and her encounters with these traditions have in turn influ-
enced her weavings.

Working with fiber on and off the loom, Hicks has produced
textiles of great diversity and originality. Her explorations of
scale have ranged from diminutive works less than a foot
long, such as her *Miniature Weaving* (pl. 40), to large-scale
commissions for architects including Kevin Roche and Eero
Saarinen. *Banisteriopsis—Dark Ink* (pl. 42), named after
an Amazonian rainforest plant that produces vividly colored
hallucinations, belongs to a series of works built from
modules of richly hued fiber clusters piled in loose configu-
rations that derive their impact from the material's plush
density. Other pieces, such as *Tresors et Secrets* (pl. 43), a
group of small "soft stones," also revel in the luxuriance of
raw thread. Hicks has suggested that, in our harsh and fast-
paced world, such works can fulfill our "need to insulate
and soften our environment to make it more peaceful,
creative, and livable."[1]

Hicks continues to explore new ways of making textiles rele-
vant to contemporary life. As she has said, "The challenge
is to continually restate or actualize the primordial textile
language, making it pertinent to our lives and progress."[2]
A recent project in this regard is her work with a Japanese
corporation on a new stainless steel thread. Impervious to
fire, frost, and water, the fiber has enormous practical appli-
cations and also gleams with an unexpected beauty.

1. Sheila Hicks, *Soft World*, exh. cat. (Tokyo: Matsuya Ginza Gallery,
 1990), p. 4.
2. Artist Statement, *Structure and Surface: Contemporary Japanese
 Textiles*, Museum of Modern Art, New York, November 12, 1998–
 January 26, 1999.

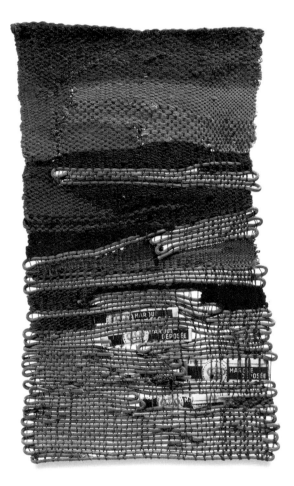

40 MINIATURE WEAVING
LATE 1980s
SILK, COTTON, BAST FIBER, WOOL,
ACRYLIC, SYNTHETIC FIBERS, PLASTIC,
AND PAPER
8⅝ × 4¾ INCHES (21.9 × 12.1 CM)
GIFT OF THE ARTIST, 1995-72-3

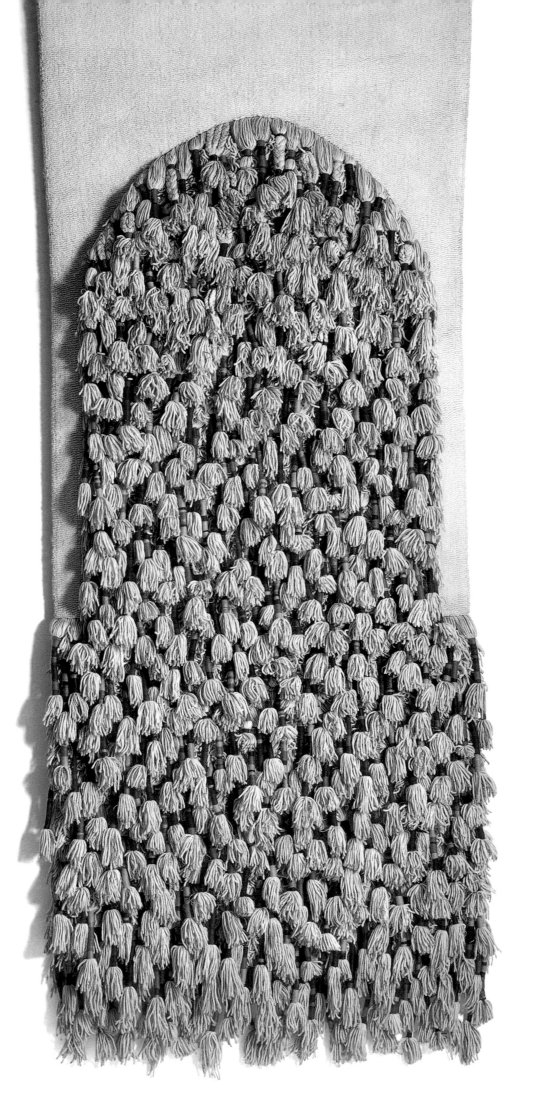

41 GRAND PRAYER RUG
1964
WOOL AND COTTON
144 x 60 INCHES (365.8 x 152.4 CM)
GIFT OF THE WOMEN'S COMMITTEE OF
THE PHILADELPHIA MUSEUM OF ART
1994-80-1

SHEILA HICKS

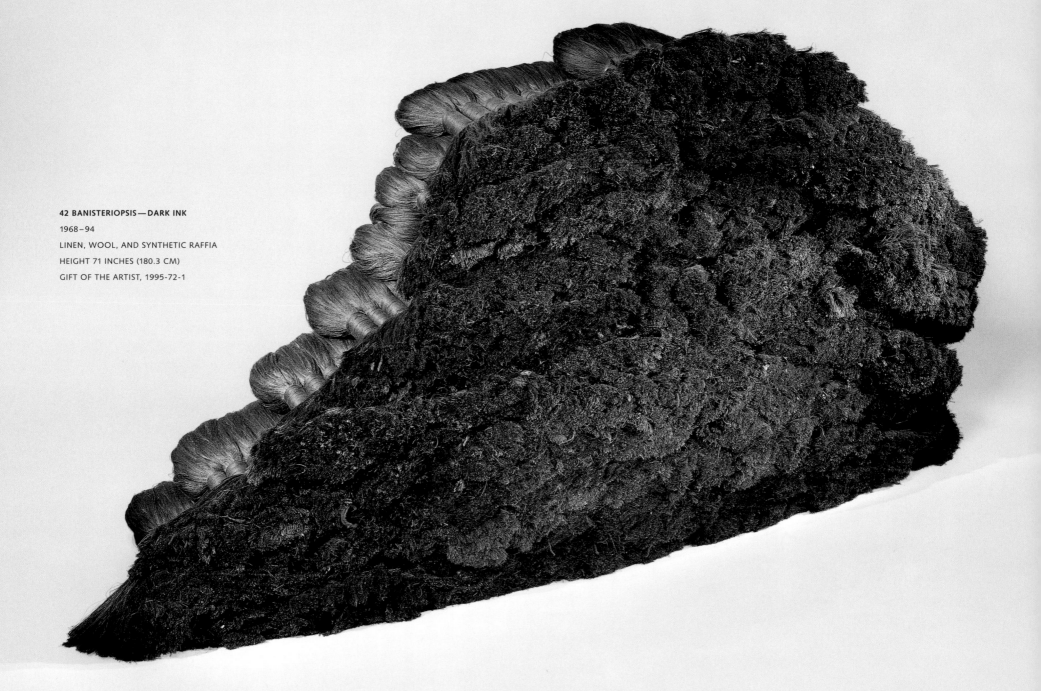

42 BANISTERIOPSIS—DARK INK
1968–94
LINEN, WOOL, AND SYNTHETIC RAFFIA
HEIGHT 71 INCHES (180.3 CM)
GIFT OF THE ARTIST, 1995-72-1

43 TRESORS ET SECRETS
1990–95
SILK, WOOL, COTTON, LINEN,
RAFFIA, AND SYNTHETIC FIBER
DIAMETER 3–9½ INCHES (7.6–24.1 CM) EACH
GIFT OF THE ARTIST
1995-15-1A–BB; 1995-72-2A–QQ

LEWIS KNAUSS

Lewis Knauss's densely textured fiber works distill memories of places in the artist's life. According to Knauss, these textiles are "intended to convey feelings beyond that of the photographic image . . . to furnish the viewer with a safe, intimate place of contemplation."[1] Indeed, his woven mementos are concentrated swatches of experience, providing much haptic as well as optic satisfaction.

Among the locales that Knauss makes manifest in his work are his home state of Pennsylvania; Saratoga, New York, where he resides part of the year; and sites in Egypt and Israel, where he has traveled. Knauss's fiber technique preserves the lush idiosyncrasies and nuances of the original landscape. Starting with a flat woven-linen ground, he attaches threads and other materials to the base, creating a loose pile of textured elements. Knauss's unorthodox approach emphasizes the ends of the fibers rather than the patterns formed by the woven strands, which get buried under the profusion of loose components.

Knauss's *Field* (pl. 44) perfectly embodies his aesthetic of abundance. As the title suggests, the textile represents a small piece of turf, from which emerges a thick growth of fibers and brightly hued flags, seemingly blowing in the wind like leafy stalks. The artist's additive approach to textiles and his attentive handling of each strand or stalk creates an energy "field" that far exceeds the weaving's modest dimensions.

1. Peggy Hobbs, "Lewis Knauss: Meditations on the Landscape,"
 Shuttle, Spindle and Dyepot 30, no.1 (Winter 1998–99), p. 19.

44 FIELD
1998
LINEN, PAPER TWINE, WIRE, PAPER, AND
ACRYLIC PAINT
HEIGHT 22 INCHES (55.9 CM)
GIFT OF THE WOMEN'S COMMITTEE OF
THE PHILADELPHIA MUSEUM OF ART
IN HONOR OF JUDITH ALTMAN
2000-55-1

RICHARD LANDIS

Although Richard Landis is a masterful weaver, he intentionally downplays his technique in favor of the overall structure of his work. Believing that "weaving is best served when materials and means are not excessive in their assertiveness,"[1] he employs an understated method to achieve his desired end of harmonious tonal variations. His technical discipline and control allow for the precisely calibrated color values in which his work revels.

Landis has chosen a fine, double plain weave as his method for exploring color systems. Typically working in a grid-like format, he sets forth subtly nuanced squares of color in various sequential relationships. A cross between poetry and mathematics, these works blend an almost scientific rigor with an intangible play of luminescent harmonies. Landis often plots out his compositions on graph paper in advance, to better coordinate the rhythms and chords of his colors.

The appropriately titled *Apollo* (pl. 45) epitomizes his approach to textile art. Like the Greek god Apollo—associated foremost with light and reason—Landis's weaving is the paragon of clarity and order. Apollo is also the god of music, and the work's harmonic play of luminous hues provides a fitting homage to this ancient deity.

1. Mildred Constantine and Jack Lenor Larsen, *Beyond Craft: The Art of Fabric* (New York: Van Nostrand Reinhold, 1972), p. 205.

45 APOLLO
1992–93
COTTON
41 x 12 INCHES (104.1 x 30.5 CM)
GIFT OF THE WOMEN'S COMMITTEE OF
THE PHILADELPHIA MUSEUM OF ART
1994-100-1

JOHN McQUEEN

Trained as a sculptor at the University of South Florida in Tampa, John McQueen first learned the art of basketry while living in New Mexico in the early 1970s. "I saw the first baskets that really excited me at the state fair—huge architectural baskets that the Indians had made," recalls McQueen. "It was when I saw those Southwest Indian baskets that I said, 'Eureka!'"[1] He soon began his own sculptural explorations of this ancient art, honing his skills at Philadelphia's Tyler School of Art, where he earned an M.F.A. in 1975.

McQueen's approach to basketry is more conceptual than practical. Unconcerned with functional issues, he is intent on redefining the limits of the basket format. Drawing creative inspiration from the quotidian landscape—from chain-link fencing to beer cartons—he has made baskets in a wide variety of scales and forms, including in the shape of letters and words. His basket-weaving technique extends beyond the repetitive over-under patterning of more common weaves and assumes a variety of structural guises. In certain works, such as the eccentrically sculptural *In the Same Bind* (pl. 48), the bark is held together through obvious stitching, in keeping with McQueen's desire to lay bare the constructive elements in his work. This work also reveals the artist's love of word play—woven into the form are the words "read" and "just," or "readjust."

McQueen instills a winning balance of nature and culture in his basketry forms. His baskets, though structurally sound, are imbued with randomness and irregularity, much of it due to his exclusive use of natural materials with all their imperfections intact. "My baskets still have the tree in them," says McQueen, "the bark, the bug marks—all those things that show they were alive."[2]

1. Barbaralee Diamonstein, *Handmade in America: Conversations with Fourteen Craftmasters* (New York: Harry N. Abrams, 1983), pp. 152, 154.
2. Betty Park, "John McQueen: The Basket Redefined," *American Craft* 39, no. 5 (October–November 1979), p. 27.

46 UNTITLED BASKET #89

1979

SPRUCE ROOTS

HEIGHT 8½ INCHES (21.6 CM)

GIFT OF MRS. ROBERT L. McNEIL, JR.

1993-79-1

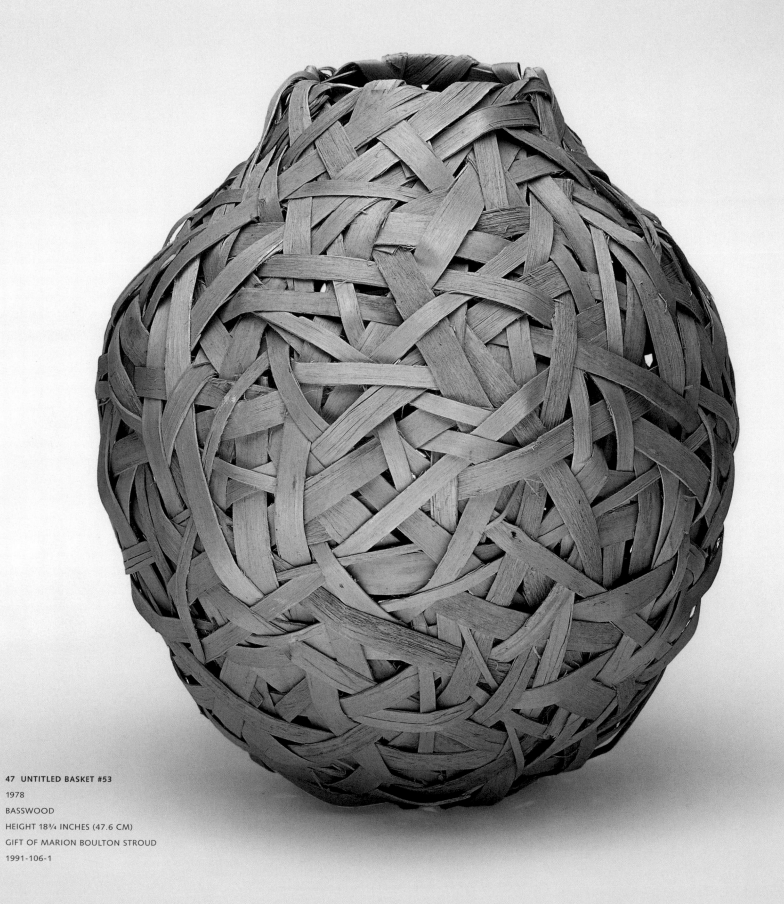

47 UNTITLED BASKET #53
1978
BASSWOOD
HEIGHT 18¾ INCHES (47.6 CM)
GIFT OF MARION BOULTON STROUD
1991-106-1

JOHN McQUEEN

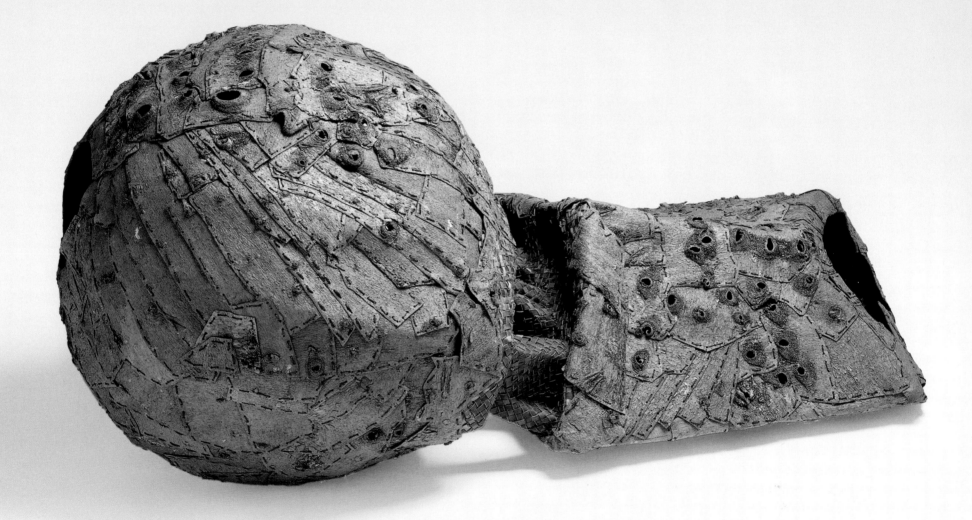

48 IN THE SAME BIND (#227)

1991

SPRUCE BARK, ELM, AND STRING

WIDTH 48 INCHES (121.9 CM)

GIFT OF MR. AND MRS. LEONARD I. KORMAN

2001-97-1

MICHAEL OLSZEWSKI

"My pieces are autobiographical,"[1] states Michael Olszewski, and he strives to achieve an emotional honesty in his nuanced textiles. Through his work Olszewski has explored such life-changing experiences as the death of his father, the loss of friends to AIDS, and his mother's struggle with Alzheimer's disease.[2] Although laden with heavy content, his work is nonetheless marked by a calm, inviting beauty that engages the viewer in the artist's revelations. Olszewski's weavings could be called a form of meditative textile, providing catharsis for both the artist and the beholder.

Olszewski began his studies at the Maryland Institute of Art, majoring in graphic design. After working briefly as an illustrator he pursued graduate study at the Kansas City Art Institute and later the Cranbrook Academy of Art in Bloomfield Hills, Michigan, where he concentrated on fiber and earned an M.F.A. in 1977. The slow, reflective process of creating textiles, as well as their ability to convey the conditions of fragility and temporality, makes them a suitable medium for expressing Olszewski's personal content.

The language of abstraction is employed in Olszewski's work to convey the desired emotional resonance. His acknowledged influences include the paintings of Mark Rothko, Kasimir Malevich, Wassily Kandinsky, and Sonia Delaunay, all of whom similarly conveyed powerful feeling through abstract means. Within textile history he cites an affinity with pre-Columbian textiles of the Nazca Indians as well as shibori dyeing techniques from Japan. All of these sources inform his subtle and complex handling of textiles as a vehicle for emotion.

Olszewski enlists a variety of techniques to achieve his expressive ends, including appliqué, embroidery, and fabric collage. His preferred materials are silk (typically from antique kimonos) and wool, which he often frays and layers to suggest time and loss. His facility at exploiting the material properties of fiber to enhance a work's meaning is finely demonstrated in *Weight of Being* (pl. 49), in which a layer of heavy wool bears down on the fragile silk below, which emerges through tattered holes.

1. Barbara Rosenblatt, "Michael Olszewski: Abstract Expression in Fabric," *Moore News* (Winter 2000), p. 29
2. Bill Scott, "Philadelphia: Michael Olszewski at Schmidt/Dean," *Art in America* (April 1994), p. 131.

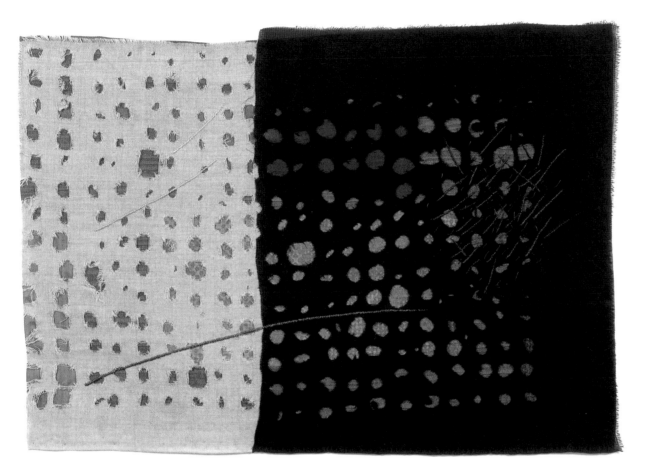

49 THE WEIGHT OF BEING
2000
SILK AND WOOL
13½ x 22 INCHES (34.3 x 55.9 CM)
PURCHASED WITH THE COSTUME
AND TEXTILES REVOLVING FUND
2000-128-1

THOMAS STEARNS

The fiber revolution of the 1950s and 1960s—spearheaded by artists such as Sheila Hicks (see pls. 40–43), Lenore Tawney (see pl. 55), and Claire Zeisler (see pl. 57)—broke away from centuries of two-dimensional weaving and demonstrated the medium's sculptural potential. Thomas Stearns's fiber sculptures exemplify this three-dimensional approach to textiles. Although Stearns studied commercial weaving in art school, he is adept at various mediums, including painting, sculpture, printmaking, and glass, and brings a distinctive sensibility to his work in fiber. Preferring natural fibers to synthetics, which he finds to be too cold, the artist enlists these organic materials to create sculptures with great mystery and presence. Stearns cultivates inscrutability in his works, seeking to lure viewers through a dense, insistent physicality.

Stearns's *Night Image #1* (pl. 54), from a larger series on the theme, is characteristic of his unique approach to the medium. Strands of fiber are draped over a softly contoured wooden form, resulting in a shrouded, spectral shape. As the title suggests, this is a figure seen in the dark, an abstracted Lady Godiva hidden in a hair-like cloak of silken fibers.

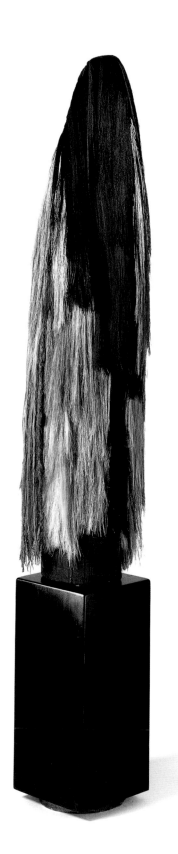

54 NIGHT IMAGE #1
1963
MIXED FIBERS ON WOODEN FORM
HEIGHT 54½ INCHES (138.4 CM)
GIFT OF MIANI JOHNSON IN MEMORY
OF HER MOTHER, MARIAN WILLARD
JOHNSON, 1992-80-1

LENORE TAWNEY

55 THE FOUNTAIN OF WORD AND WATER
1963
LINEN
HEIGHT 162 INCHES (411.5 CM)
GIFT OF THE WOMEN'S COMMITTEE OF
THE PHILADELPHIA MUSEUM OF ART
1994-23-1

Lenore Tawney literally ripped a hole through traditional weaving practice. Born in Ohio, she moved to Chicago in 1927, where she took classes at the Art Institute of Chicago. After two years at the University of Illinois in Urbana and a stay in Mexico, she returned to Chicago in 1946 to attend the Institute of Design, where she studied with the Russian-born Cubist sculptor Alexander Archipenko. Tawney soon shifted her focus from sculpture to weaving, a medium that she would radically transform.

In 1954, after several years spent living in Paris and traveling extensively in Europe and North Africa, Tawney studied tapestry at the Penland School of Crafts in North Carolina. Her early works feature representational imagery on the flat, rectangular field of traditional tapestry, but she soon began to embrace greater abstraction and a more sculptural, open-structure weave.

Tawney departed from standard weaving practice in a number of ways. Instead of a continuous woven surface, she created works with open areas of unwoven warp, allowing space and transparency to enter the textile. Like Sheila Hicks (see pls. 40–43) and Claire Zeisler (see pl. 57), she began manipulating the surface grid of the weaving, which resulted in dimensional works that no longer hung flat on the wall. Tawney's sculptural weavings moved out into the center of the room, incorporating the environment and light around them. As her work evolved, it assumed near-monumental proportions and increased sculptural impact through a subdued monochromatic palette.

Tawney's *Fountain of Word and Water* (pl. 55) embodies many of the features for which the artist is noted, including open structure, large scale, and a totemic presence. *Fountain* belongs to a series of tall, narrow weavings Tawney created in the early 1960s, which she says were "constructed as expanding, contracting, aspiring forms."[1] The title, which was suggested by the painter Agnes Martin, points to Tawney's recurring iconography of natural elements—earth, water, air—as well as a deep spirituality informed by Eastern philosophy.

1. Martin Eidelberg, ed., *Design 1935–1965: What Modern Was*, exh. cat. (Montreal: Musée des arts décoratifs de Montréal, 1991), p. 298.

FURNITURE

Wendell Castle
John Cederquist
Wharton Esherick
James Krenov
Sam Maloof
Wendy Maruyama
Judy Kensley McKie
George Nakashima

WENDELL CASTLE

Wendell Castle's furniture, like his background, merges the functional and the sculptural. With a B.A. in industrial design and an M.F.A. in sculpture, Castle brings a blend of practical and artistic experience to his furniture-making. He was the first artist to fully realize the creative potential of the industrial stack lamination process, which he employed to expressive ends in his sculptural furniture.

Whereas large pieces of solid wood easily crack due to changes in temperature and moisture, stack lamination allows for larger sculptural volumes. This process has given Castle great flexibility in his furniture, as seen in the sinuously taut contours of works such as his 1972 *Music Stand* (pl. 59). Castle's formal range is further revealed in the jaunty angularity of *Ladder of Eurus* (pl. 60), a curiously unnecessary piece of equipment for the winged Greek god of the east wind. Although it does not function as a ladder, it is equipped with a small cabinet in its uppermost section.

In the mid-1970s, Castle embarked on a series of pieces that combine traditional woodworking techniques with playful trompe l'oeil elements. In these wooden deceptions, convincing historical furniture types are embellished with casually placed carved objects, as in the *Table with Gloves and Keys* (pl. 58), an elegant Federal-style table on which the artist has carved a pair of fur-lined gloves and a set of keys. Castle has asserted that "art should call things into question. . . . Uncertainty is good. Uneasy relationships keep one awake."[1] Indeed, these playfully ambiguous works take delight in challenging our perception.

1. Peter T. Joseph et al., *Masterworks*, exh. cat. (New York: Peter Joseph Gallery, 1991), p. 24.

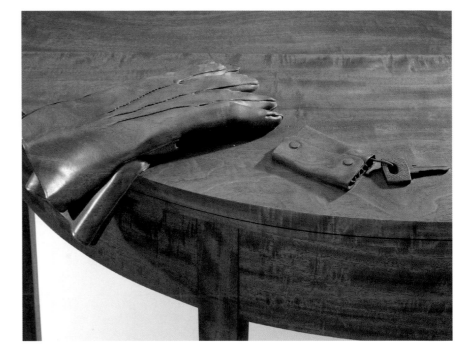

DETAIL

58 TABLE WITH GLOVES AND KEYS

1980

MAHOGANY

HEIGHT 34½ INCHES (87.6 CM)

GIFT OF MRS. ROBERT L. McNEIL, JR.

2001-15-1

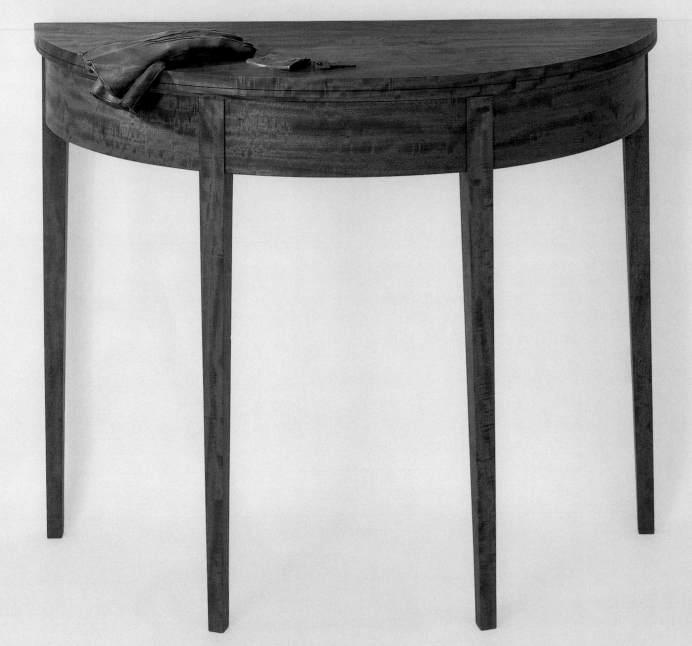

WHARTON ESHERICK

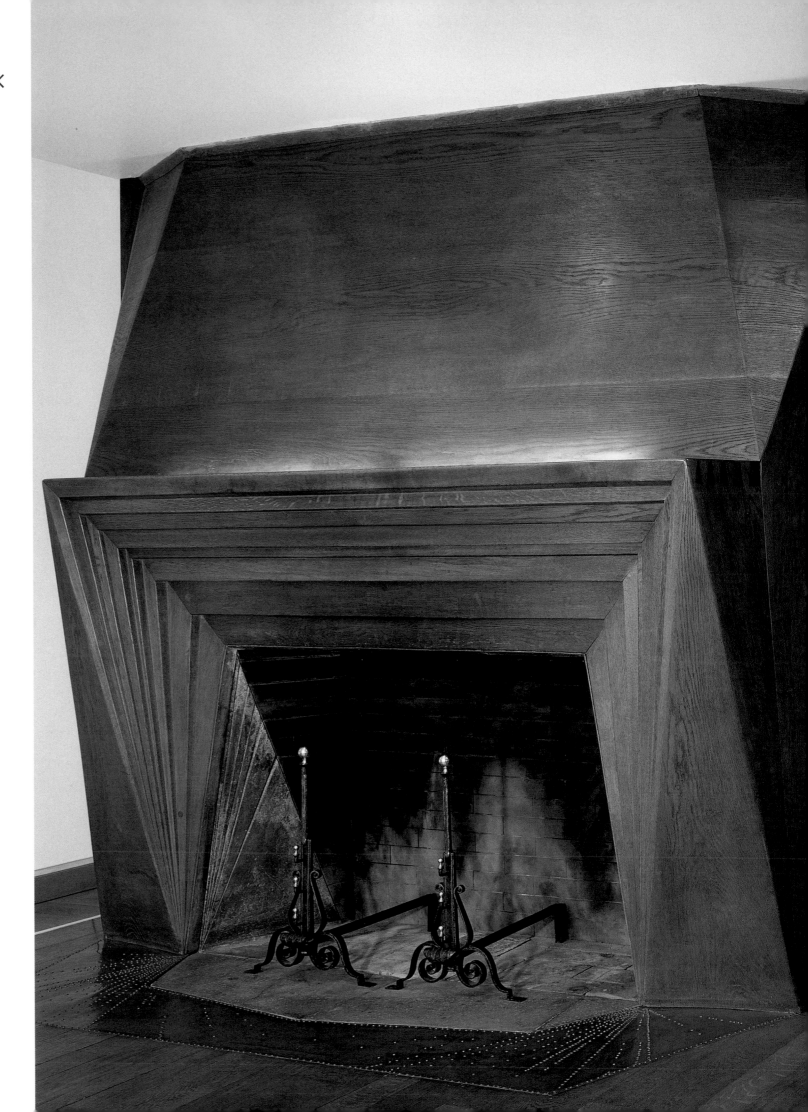

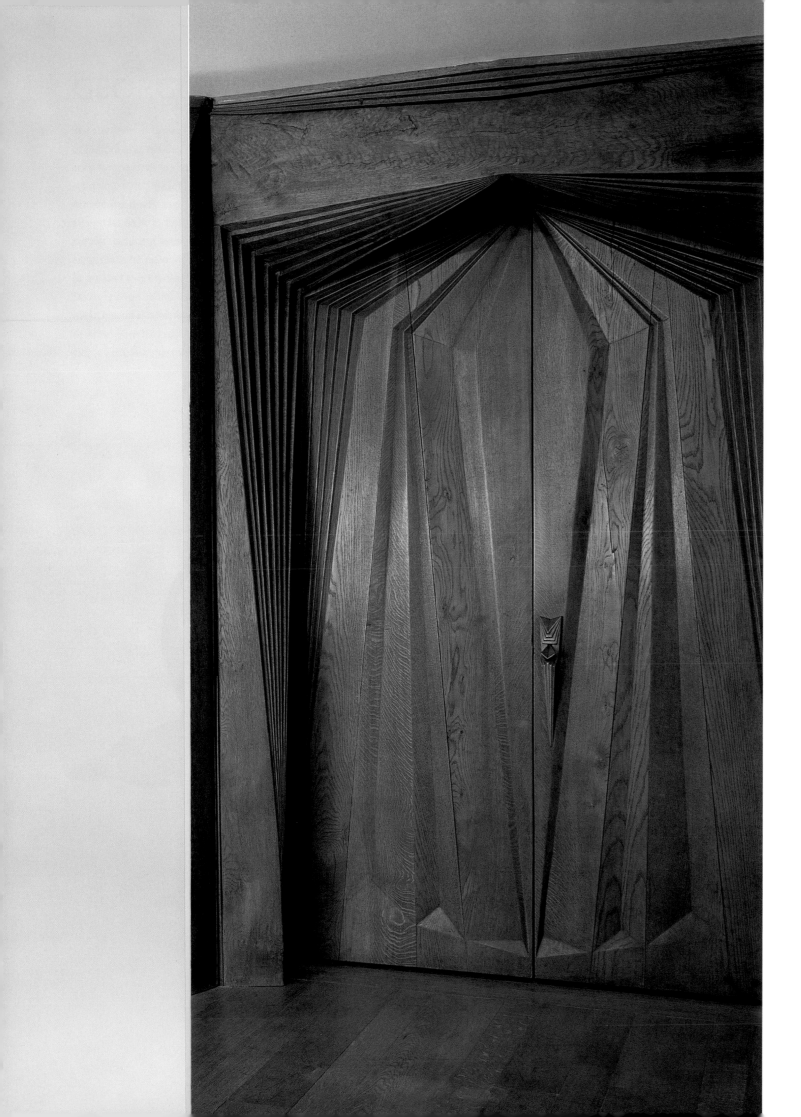

64 FIREPLACE AND DOORWAY

FROM THE LIBRARY AND MUSIC ROOM OF THE CURTIS

BOK HOUSE, GULPH MILLS, PENNSYLVANIA

1936–37

WHITE OAK, STONE, COPPER, AND BRASS

102 × 192 × 60 INCHES (259.1 × 487.7 × 152.4 CM)

ACQUIRED THROUGH THE GENEROSITY OF W. B.

DIXON STROUD, WITH ADDITIONAL FUNDS FOR ITS

PRESERVATION AND INSTALLATION PROVIDED BY

DR. AND MRS. ALLEN GOLDMAN, MARION BOULTON

STROUD, AND THE WOMEN'S COMMITTEE OF THE

PHILADELPHIA MUSEUM OF ART, 1989-1-1, 2

WEND[
MARU[

One of the few s
a male-dominate
cleared a bold pa
tional furniture-r
Program in Artist
1980 from Roche
the creative licen
group Memphis,
ends in furniture-

Maruyama explo
route to her mate
investigating the
painting her surfa
positions. In the
color, painting or
ring to this work
presented it as w
made manifest in

Following this rel
her exploration o
forms. Having go
now balances con
features unexpec
tion, function and
curves. A fine exa
found in her 1990
a standard furnitu
statement with sl
across the facade

1. Edward S. Cooke,
 Generation of Stu
 1989), p. 74.

Howard Ben Tré
Dale Chihuly
Dominick Labino
Harvey Littleton
Richard Marquis
Tom Patti
Judith Schaechter
Toots (Mary Ann) Zynsky

GLASS

HOWARD BEN TRÉ

Enlisting the three-thousand-year-old Egyptian technique of sand casting, Howard Ben Tré creates glass sculptures that unite a timeless formal quality with modern industrial elements. Impatient with the limits of glassblowing, Ben Tré began experimenting with cast glass during a 1976 summer residency at the Pilchuck Glass School near Seattle, using methods he had learned in a metal shop class at Brooklyn Technical High School. He has since emerged as a pioneer in the use of cast glass as a medium for large-scale sculpture.

The casting technique results in a number of distinct properties that have become hallmarks of Ben Tré's glass sculptures. Sand-and-resin molds produce a rough, grainy texture, with pits and abrasions instead of the smooth, icy surfaces found in much studio glass. This textural surface has proved to be richly evocative, suggesting the erosive effects of time and decay. Ben Tré's inclusion of metal elements laminated onto the glass, often with gold leaf, adds to the warmth of these works. The unpurified, industrial glass that Ben Tré employs—the same factory glass used to make windows and lampshades—retains a green cast from iron oxides. The milky radiance of this semi-opaque glass also imparts its own character on the artist's finished forms.

Ben Tré has developed a means of casting large-scale glass forms that can withstand the stress of climatic change, allowing him to bring a traditionally fragile medium into the rugged outdoors. His public commissions include outdoor glass sculptures for Post Office Square in Boston and the Rhode Island Convention Center in Providence.

In addition to his interest in ancient casting processes, Ben Tré has also found inspiration in architecture, particularly Egyptian, pre-Columbian, classical Greek, and Gothic structures. In his two early floor-based series, "Structures" (pl. 73) and "Columns," he created totem-like sculptures that refer to ancient temple architecture as well as modern construction elements such as bridge and highway supports.

Ben Tré has said, "My intention is to make provocative objects, objects which are referential."[1] The generic titles and forms of his sculptures allow for diverse interpretations, and critics have found numerous associations in Ben Tré's forms. His "Columns," for example, have been read as phallic containers of semen-like fluid, and his earlier round, slitted forms as their female counterparts.[2] Such interpretations provide further testament to the evocative character of Ben Tré's radiant works.

1. Linda L. Johnson, "Howard Ben Tré: Paradox and Harmony," in *Howard Ben Tré: Contemporary Sculpture,* exh. cat. (Washington, DC: The Phillips Collection, 1989), p. 20.
2. Matthew Kangas, "Engendering Ben Tré," *Glass* (Spring–Summer 1990), pp. 20–27.

73 STRUCTURE 23

1984

GLASS AND COPPER

HEIGHT 41 INCHES (104.1 CM)

GIFT OF THE WOMEN'S COMMITTEE OF

THE PHILADELPHIA MUSEUM OF ART

1985-54-1

DALE CHIHULY

Dale Chihuly began his artistic career as a student of weaving, so it is only fitting that his first foray into glass dealt with the textile tradition, specifically, Navajo blankets. In 1959 Chihuly entered the University of Washington, Seattle, to study interior design and architecture. After a hiatus in 1961–62, during which he traveled throughout Europe and the Middle East, he returned to the university and shifted his attention to weaving. He soon began incorporating glass into his large tapestries, providing a foretaste of things to come. In 1966 he received a scholarship to study with glass pioneer Harvey Littleton (see pls. 77, 78) at the University of Wisconsin, Madison. He continued his studies, concentrating on multimedia sculpture and environmental works, at the Rhode Island School of Design in Providence, where he earned an M.F.A. in 1968. Upon graduation, Chihuly spent a year in Venice on a Fulbright Fellowship, immersing himself in the forms and techniques of traditional glassblowing.

Chihuly's first series in glass was his 1974–75 "Navajo Blanket Cylinders," which transpose Indian blanket patterns onto the surface of thick-walled vessels. In works such as *Chief Pattern Blanket* (pl. 74), which develops motifs from a tribal chief's textile wrap, thin glass rods and threads were arranged in woven patterns and then fused onto the molten surface of the cylinder. The glass weaving is permanently embedded in the wall of the vessel, hovering on the surface like a drawing in space. Indeed, these early works are as much about draftsmanship as they are about sculptural form.

Native American traditions also informed Chihuly's next series of glass "Baskets," begun in 1977, in which he introduced the rippling, organically irregular forms for which he is known. This group in turn spawned Chihuly's series of "Nested Bowls" (pl. 75) in the early 1980s, featuring a bold color palette and contrasting treatment of interior and exterior surfaces. These dynamic vessels multiply into small families, nesting and clustering. The "Nested Bowls" demonstrate Chihuly's bravura use of color and ability to create animated forms, conveying the fluidity of glass captured in its molten state.

74 CHIEF PATTERN BLANKET
1975
GLASS
HEIGHT 7½ INCHES (19.1 CM)
GIFT OF THE WOMEN'S COMMITTEE OF
THE PHILADELPHIA MUSEUM OF ART
1998-86-1

75 FIVE NESTED GLASS BOWLS

BEFORE 1982

GLASS

DIAMETER 8–23 INCHES (20.3–58.4 CM) EACH

GIFT OF MILTON C. BICKFORD, JR.

1983-166-1A–E

HARVEY LITTLETON

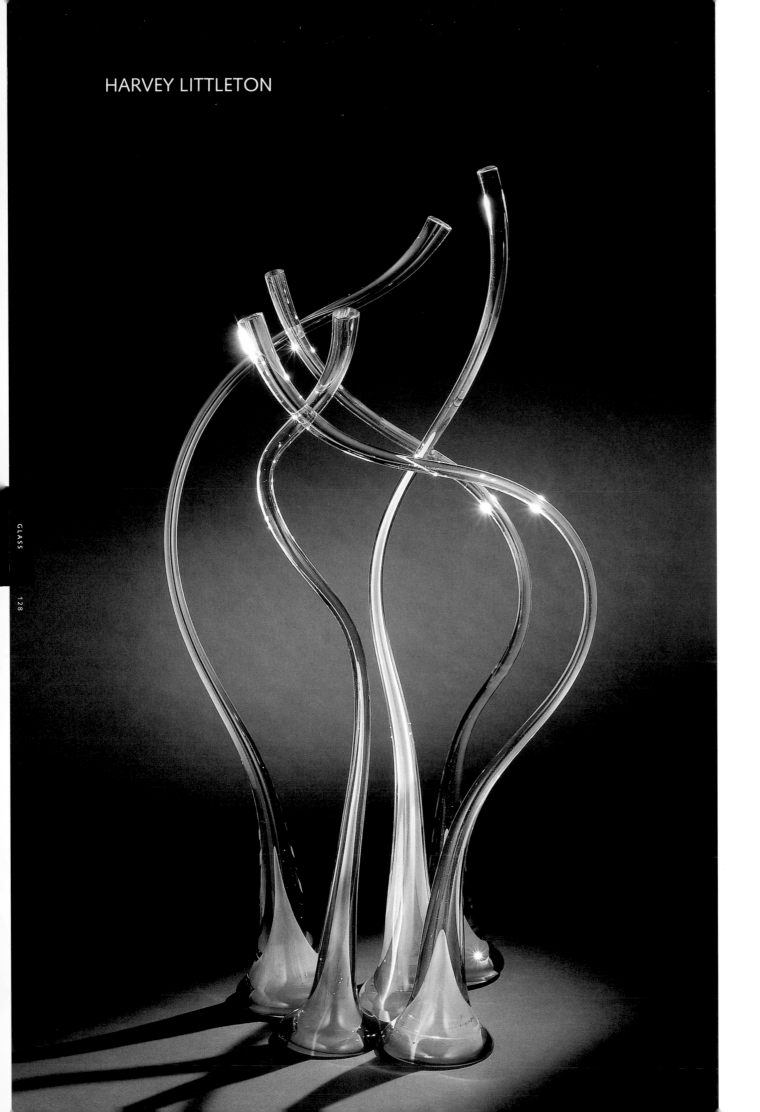

78 IMPLIED MOVEMENTS

1986

GLASS

HEIGHT 34½–41½ INCHES (87.6–105.4 CM) EACH

GIFT OF MRS. ROBERT L. McNEIL, JR.

1998-83-12A–E

RICHARD MARQUIS

At once playful and masterful, Richard Marquis's glass work is a distinct blend of New World sensibility and Old World craftsmanship. Marquis became interested in glass while studying ceramics with Peter Voulkos (see pl. 32) at the University of California, Berkeley, and continued to work in both mediums from the mid-1960s to the early 1970s. While a student, Marquis was steeped in the California Funk aesthetic, which was characterized by irreverence and controversial content. This early influence was tempered by the impact of the "finish-fetish" ceramics of California artists such as Kenneth Price (see pls. 20, 21) and Ron Nagle (see pl. 14). A resulting mixture of the raunchy and refined would mark Marquis's work in the decades to come.

The California imprint would be further modified by Marquis's experiences in Italy. In 1969 he was awarded a Fulbright Fellowship to work on the famed Venetian island of Murano. It was here that he learned the ancient technique of murrine, on which he would base much of his glass art. Murrine involves joining thin canes of multicolored glass into larger clusters that are then cut into slices and fused onto vessels, for a mosaic-like effect. In characteristic fashion, Marquis enlisted this revered Italian method to create a series of American-flag pieces and works featuring profane language. He also began creating the lively murrine teapots for which he is best known.

Marquis's most virtuoso use of the murrine technique is found in his "Marquiscarpa" series (pl. 79), begun in 1989. These goblets draw on diverse historical precedents, including traditional chalices, African headrests, and ancient Greco-Roman drinking cups. The title alludes to the glassware of Carlo Scarpa, an architect who designed murrine glass for Venini Fabbrica in the 1930s and 1940s. Marquis cannot resist leavening these elegant and technically adroit works with an element of whimsy, embedding hidden imagery within the mosaic glass patterns, including cats, dogs, and his signature teapots.

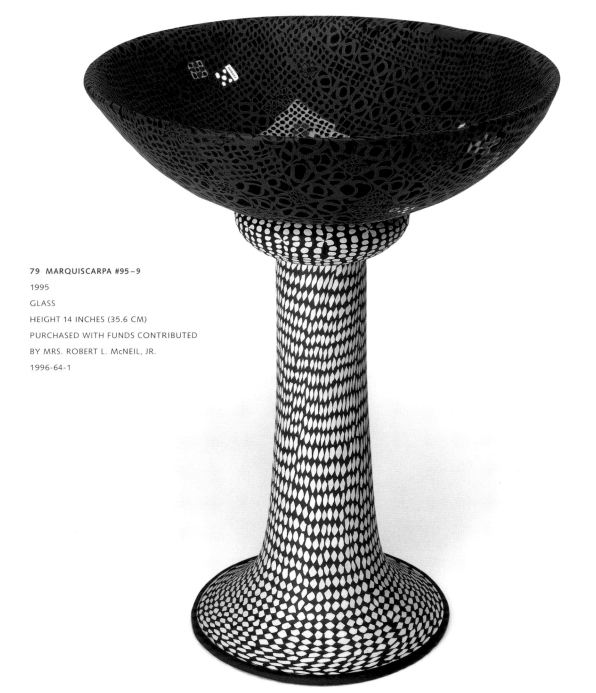

79 MARQUISCARPA #95–9
1995
GLASS
HEIGHT 14 INCHES (35.6 CM)
PURCHASED WITH FUNDS CONTRIBUTED
BY MRS. ROBERT L. McNEIL, JR.
1996-64-1

Chunghi Choo
William Harper
Stanley Lechtzin
Albert Paley
Richard Hoffman Reinhardt
Olaf Skoogfors

METAL

STANLEY LECHTZIN

Stanley Lechtzin has made a career out of transforming impersonal industrial technologies into distinctly original works. According to the artist, "I attempt to create personal values with materials and processes which today are used in a mechanical and anonymous manner by industry."[1]

After receiving his M.F.A. from the Cranbrook Academy of Art in Bloomfield Hills, Michigan, in 1962, Lechtzin moved to Philadelphia to head the Tyler School of Art's new metal and jewelry department. In the 1960s and 1970s, his experiments with electroforming—an industrial process for metal-plating modeled forms—placed him at the forefront of the American jewelry movement and helped establish Philadelphia as a major center for innovative metalwork. Though the process dates to the early nineteenth century, Lechtzin was the first to adapt it for artistic purposes. In his work, Lechtzin took full advantage of electroforming's potential to yield large-scale objects that are relatively light, allowing him to create full-bodied yet wearable sculptural forms. He also exploited the organic structures that "grow" in the acid bath during the process. These metal accretions bear a welcome resemblance to natural forms found in plants or geological structures.

Lechtzin next turned his attention to the creative potential of plastics, reveling in their wide color palette and transparent light effects. The great variety of this man-made material held such appeal for the artist that his jewelry became increasingly dominated by plastic rather than metal. The 1972 piece *Torque* (pl. 86) is a finely balanced blend of the two materials, showcasing both Lechtzin's electroforming skill and his deft handling of plastic. Characteristic of his work during this period, it is highly organic and baroque in its muscular curves.

In the mid-1980s Lechtzin became enamored with yet another means of technology, namely the computer. Since then, he has virtually abandoned handwork, believing that the computer has rendered such labor-intensive techniques redundant. Unlike Lechtzin's earlier organic forms, his computer-generated designs and objects reveal a more geometric structure.

1. *Philadelphia: Three Centuries of American Art* (Philadelphia: Philadelphia Museum of Art, 1976), p. 614.

86 TORQUE
1972
SILVER, GILDED, AND POLYESTER
LENGTH 12⅛ INCHES (30.8 CM)
GIFT OF THE FRIENDS OF THE
PHILADELPHIA MUSEUM OF ART
1973-94-7

David Ellsworth
Gyöngy Laky
Mark Lindquist
Edward Moulthrop
James Prestini
Robert Stocksdale

WOOD

GYÖNGY LAKY

Born in Budapest, Hungary, during World War II, Gyöngy Laky grew up playing among the twisted vines of her family's vineyard. Although her family was forced to flee Hungary for the United States when Laky was five because of her father's role in the Resistance, these early years in Europe left an imprint that would later emerge in her art. In the 1960s Laky entered the University of California, Berkeley, where she studied with textile designer and fiber artist Ed Rossbach (see pls. 50, 51) and earned a graduate degree in design. She founded the Fiberworks Center for the Textile Arts, a renowned Berkeley gallery and educational center, which operated from 1973 until 1987.

The works Laky completed following graduation combined organic and synthetic materials such as plastic-wrapped wood or rope, perhaps as a commentary on humankind's threat to nature. Even in these early works she incorporated twigs, which became her signature material. Laky gathers her material from the prunings and trimmings left over from maintenance of orchards, parks, and gardens, giving these unwanted plant parts a second life in her work. Her use of these throwaways speaks to her ongoing concern for the environment. As the artist puts it, "I am interested in making a small dent in changing attitudes about the environment and our relationship to it. I want to propose the question of what is waste and what is not."[1]

Laky fashions these rescued twigs into a wide range of forms, using dowels or nails to assemble her structures. Whereas sculptures such as *Evening* (pl. 95) are loose renditions of vessel forms, others assume the shape of words. These one-word statements, sometimes realized on a monumental scale, allow the once-neglected prunings to "talk back," letting nature have the last word.

1. Gyöngy Laky, "Artist Statement," *FiberScene* <http://www.fiber scene.com/artists/g_laky.html> (accessed April 1, 2002).

95 EVENING
1995
SYCAMORE
HEIGHT 21 INCHES (53.3 CM)
GIFT OF THE WOMEN'S COMMITTEE OF
THE PHILADELPHIA MUSEUM OF ART
1998-10-4

MARK LINDQUIST

Mark Lindquist was introduced to wood turning at the age of ten by his father Melvin, an engineer who was also a major figure in the modern turning field. Although raised with woodworking, Mark Lindquist chose to study painting, sculpture, and ceramics, apprenticing with a Buddhist potter for two years. He also studied Eastern philosophy and aesthetics, which later influenced his free approach to turned wood.

When Lindquist returned to woodworking in the early 1970s, he teamed up with his father to explore the creative and technical potential of the medium. In keeping with Eastern aesthetics, he came to value the wood's flaws and irregularities and became especially adept in the use of spalted wood. The product of water and fungus invading a tree, spalting is a process of decay that leaves discolored lines as it advances through the wood. The graphic patterns that emerge from this process have been a source of inspiration for both Lindquist and his father.

Lindquist's acceptance of accidental effects has led him to develop unorthodox methods for shaping his forms. Recalling unintended gouges he made in an early turned bowl, Lindquist decided to cultivate the intensity and texture of this crude wood treatment. He also introduced the use of chainsaws into the lathing process, creating forms with raw surfaces and sculptural potency.

Lindquist's *Unsung Bowl #4* (pl. 96), a pun on the Sung dynasty pottery that once inspired him, beautifully unites his love of spalted wood patterns with his daring pursuit of expressionistic surfaces. It is also a testament to his sculptural aspirations even when making a seemingly functional object. As Lindquist explains, "It is wrong to ask the spalted bowl to function as a workhorse as well, to hold potato chips, or salad or to store trivialities. The bowl is already full. It contains itself and the space between the walls."[1]

1. Robert Hobbs, *Mark Lindquist: Revolutions in Wood* (Richmond, VA: Hand Workshop Art Center, 1995), p. 10.

96 UNSUNG BOWL #4
1982
SPALTED MAPLE
DIAMETER 18 INCHES (45.7 CM)
GIFT OF THE WOMEN'S COMMITTEE OF
THE PHILADELPHIA MUSEUM OF ART
1982-70-1

EDWARD MOULTHROP

A former architect, Edward Moulthrop practiced wood turning as a hobby until 1974, when he decided to devote himself solely to the art. His architectural background finds expression in the refined structure and ambitious scale of his bowls. Recognized as a pioneer in the development of large-scale turned vessels, he has created circular bowls more than three feet in diameter, as wide as the tree trunk from which they were turned. To achieve such scale, Moulthrop has had to devise his own tools and lathes to accommodate logs weighing more than a thousand pounds. The impressive size of these works is also made possible by the special solution in which he steeps the fresh wood to prevent it from splitting and cracking.

Moulthrop avoids accidental effects during the turning process, but he cherishes such mishaps when found in nature. Although he uses a number of different woods—including cypress, black walnut, wild cherry, sweet gum, magnolia, and sugarberry—he is repeatedly drawn to the striking patterns of the tulip poplar, as found in his *Figured Ellipsoid* (pl. 97). Moulthrop is especially attracted to tulip-wood that has been struck by lightning, rendering it subject to decay and bacteria that produce bold streaks of red and purple. He accentuates this already dramatically figured wood by the shaping and surface treatment of his turning.

Moulthrop's works owe much of their beauty to his respect for the wood's natural grain and character. As the artist explains, "It can be said that each bowl already exists in the trunk of the tree, and one's job is simply to uncover it and somehow chip away the excess wood, much as you would chip away the surrounding stone to uncover a perfect fossil entombed in the stone."[1]

1. Edward Moulthrop, Artist Statement, Joanne Rapp Gallery/The Hand and the Spirit, Scottsdale, Arizona.

97 FIGURED ELLIPSOID

c. 1980

TULIPWOOD

HEIGHT 12 INCHES (30.5 CM)

GIFT OF MRS. ROBERT L. McNEIL, JR.

1997-10-3

JAMES PRESTINI

Although James Prestini had a significant impact on the field, wood turning was always a hobby for him, not a profession. After receiving a degree in mechanical engineering from Yale, Prestini moved to Chicago to study at the Institute of Design. There he met a number of artists and architects associated with the American Bauhaus movement, especially the school's Hungarian-born director, László Moholy-Nagy, whose ideas about the relationship between art and industry influenced Prestini. Moholy-Nagy saw the potential for designers to raise the quality of life for millions by producing well-designed and inexpensive functional objects. Prestini came to believe that training in handcraft was an important means of sensitizing designers to the nuances of form and material.

Prestini started wood turning in 1933, at the age of twenty-five, and for the next twenty years he created carefully calibrated bowls and platters that are a testament to his engineering skill and technological prowess. Not surprisingly, his finely hewn works reveal the impact of the Bauhaus aesthetic, as evidenced in the group of bowls in the Philadelphia Museum's collection (pls. 98–101). Although individually handmade, they have a precision and uniformity typically found in mass-produced industrial goods. And while there is a delicacy to his simple objects, the treatment is evenhanded and uninflected. Prestini's strict variations on basic shapes reveal his accord with the formal vocabulary of mechanized production.

98 BOWL #35
1946
EBONIZED ASH
DIAMETER 9⁷⁄₈ INCHES (25.1 CM)
GIFT OF THE ARTIST, 1979-167-9

99 BOWL #92
1950
CHESTNUT
DIAMETER 8⅝ INCHES (21.9 CM)
GIFT OF THE ARTIST, 1979-167-8

JAMES PRESTINI

100 BOWL #24
1949
MEXICAN MAHOGANY
DIAMETER 11³/₁₆ INCHES (28.4 CM)
GIFT OF THE ARTIST, 1979-167-10

1947

CURLY BIRCH

DIAMETER 10⁵⁄₁₆ INCHES (26.2 CM)

GIFT OF THE ARTIST, 1979-167-12

ROBERT STOCKSDALE

Robert Stocksdale's wood-turning career began in a federal detention camp in California. Detained as a conscientious objector during World War II, Stocksdale was put to work fighting fires and building park trails. While interned, he arranged to have his cabinetmaking tools delivered to help him pass the time. He soon began turning bowls, a skill he has perfected during more than fifty years in the field.

Following the war, Stocksdale settled in Berkeley, California, with his wife, artist Kay Sekimachi, and set up shop turning salad bowls and other functional vessels. While his forms have evolved over the decades, he has remained committed to producing elegant, well-turned bowls. As he acknowledges, "Over the years I sought refinement of the form, not innovation."[1] In spite of his understated style, he has proved to be an influential figure for many contemporary wood turners.

Stocksdale approaches each piece with an eye to the wood's intrinsic qualities. "The shape of a log, the grain pattern, cracks, faults, or rotten spots all play a part in my discovery of new shapes,"[2] he explains. Drawn to exotic wood species such as kingwood, ziricote, or the Philippine ebony used in his 1986 *Bowl* (pl. 102), Stocksdale accentuates the inherent beauty of the wood's grain and color through his carefully contoured forms.

1. Albert B. LeCoff, *Lathe-Turned Objects* (Philadelphia: Woodturning Center, 1988), p. 147.
2. Ibid.

102 BOWL
1986
PHILIPPINE EBONY
DIAMETER 10¾ INCHES (27.3 CM)
GIFT OF THE WOMEN'S COMMITTEE OF
THE PHILADELPHIA MUSEUM OF ART
1987-49-1

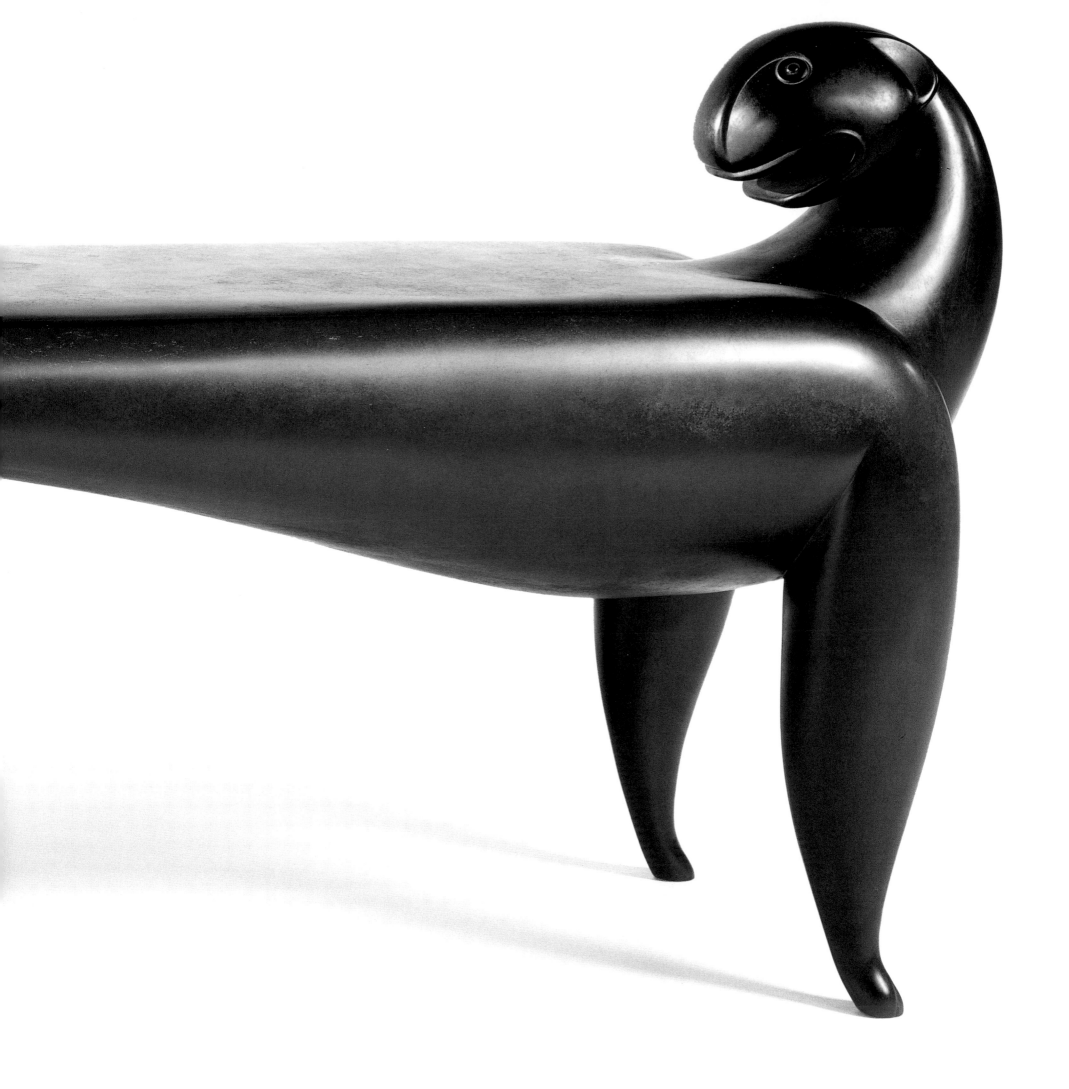

CERAMICS

1. ROBERT ARNESON
American, 1930–1992
David (David Gilhooly), 1977
Earthenware, glazed
Height 35 inches (88.9 cm)
Purchased with the Baugh-Barber Fund
1977-126-1
Pl. 1

2. MICHAEL ARNTZ
American, born 1939
Covered Jar, 1973
Stoneware, glazed
Height 12 inches (30.5 cm)
Purchased with funds contributed by
Mrs. William P. Lowry
1973-97-1a, b

3. BENNETT BEAN
American, born 1941
Untitled (Double Series), 1998
Earthenware, acrylic, and gold leaf
Height (1991-1-1a) 13½ inches (34.3 cm);
(1991-1-1b) 14¼ inches (36.2 cm)
Gift of The Women's Committee of the Philadelphia
Museum of Art in honor of Nancy M. McNeil
1999-1-1a, b
Pl. 2

4. JILL BONOVITZ
American, born 1940
Softly Sighing, 1989
Earthenware, terra sigillata
Diameter 26 inches (66 cm)
Gift of the Robert H. and Janet S. Fleisher Foundation
1991-104-1

5. BETSY BRANDT
American, born 1961
Crayola Urn, 1988
Earthenware, glazed
Height 24 inches (61 cm)
Gift of The Women's Committee of the Philadelphia
Museum of Art
1989-20-1*

6. MARK BURNS
American, born 1950
Monkey Trouble Tureen, c. 1993
Porcelain, glazed ceramic, and mixed media
Height 30 inches (76.2 cm)
Gift of the artist and Helen Williams Drutt English
1993-77-1a–c*

7. ROSE CABAT
American, born 1914
Feelie, 1958
Porcelain, glazed
Height 6⅛ inches (15.6 cm)
Gift of Frederick James Kent in memory of John R. Angell
1986-103-1*

8. ROSE CABAT
Feelie, 1960
Porcelain, glazed
Height 4½ inches (11.4 cm)
Gift of Frederick James Kent in memory of John R. Angell
1986-103-2

9. ROSE CABAT
Feelie, 1985
Porcelain, glazed
Height 5½ inches (14 cm)
Gift of the Mulcahy Foundation
1988-24-1

10. ROSE CABAT
Feelie, 1985
Porcelain, glazed
Height 4 inches (10.2 cm)
Gift of the Mulcahy Foundation
1988-24-2

11. PETER CALLAS
American, born 1951
Tea Bowl (in Seto Style), 1996
Stoneware, glazed
Diameter 5 inches (12.7 cm)
Gift of Charles Cowles Gallery, New York
1997-7-1

THE COLLECTION

5

6

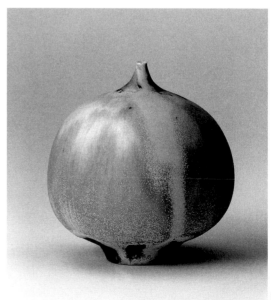

7

12. SYD CARPENTER
American, born 1953
A Snake without a Head Is Just a Rope, 1994
Earthenware, glazed
Length 60 inches (152.4 cm)
Gift of The Women's Committee of the Philadelphia
Museum of Art
1995-19-1*

13. CLAUDE CONOVER
American, 1907–1994
Heklay, 1982
Stoneware, glazed
Height 23¼ inches (59.1 cm)
Gift of Mr. and Mrs. Leonard I. Korman
1982-124-1

14. ANNETTE CORCORAN
American, born 1930
Red Shouldered Hawk Teapot, 1987
Porcelain, glazed
Height 8 inches (20.3 cm)
Gift of Mr. and Mrs. Leonard I. Korman
1987-46-1a, b*

15. VAL CUSHING
American, born 1931
Covered Jar, c. 1970
Stoneware, glazed
Height 8⅜ inches (21.3 cm)
Gift of Frederick James Kent in memory of John R. Angell
1986-103-5

16. WILLIAM DALEY
American, born 1925
Vessel, 1974
Stoneware, unglazed
Height 33½ inches (85.1 cm)
Purchased with the Baugh-Barber Fund
1976-251-1
Pl. 3

17. RICHARD DeVORE
American, born 1933
Bowl, 1974
Stoneware, glazed
Height 7¾ inches (19.7 cm)
Purchased with the George W. B. Taylor Fund
1975-96-1
Pl. 5

18. RICHARD DeVORE
Bowl, 1976
Stoneware, glazed
Diameter 10½ inches (26.7 cm)
Gift of the artist
1977-2-1
Pl. 4

19. RICHARD DeVORE
Untitled Vessel, 1980
Stoneware, glazed
Height 16¼ inches (41.3 cm)
Gift of The Women's Committee of the Philadelphia
Museum of Art
1991-8-1
Pl. 6

20. RICHARD DeVORE
No. 584, 1988
Stoneware, glazed
Height 16 inches (40.6 cm)
Bequest of Edna S. Beron
1996-2-3

21. RUTH DUCKWORTH
British, active United States, born Germany, 1919
Demitasse and Saucer, 1960–61
Stoneware, glazed
Height (demitasse) 3⅛ inches (7.9 cm);
diameter (saucer) 5 inches (12.7 cm)
Gift of Helen Williams Drutt
1973-233-1a, b

22. RUTH DUCKWORTH
Vessel, 1979
Porcelain, glazed
Height 5 inches (12.7 cm)
Gift of Collab: The Group for Modern and
Contemporary Design at the Philadelphia
Museum of Art, with funds contributed by
Samuel R. Berman
1979-31-1

23. RUTH DUCKWORTH
Untitled (#33387), 1987
Stoneware, glazed
Height 21½ inches (54.6 cm)
Gift of The Women's Committee of the Philadelphia
Museum of Art
1992-5-1
Pl. 7

24. MARY FRANK
American, born England, 1933
Figure of Running Man, 1977
Earthenware with applied slip
Height 11¾ inches (29.8 cm)
Gift of Pat Adams
1978-176-1

25. VIOLA FREY
American, born 1933
The Red Hand, 1983–84
Ceramic, glazed
Height 62 inches (157.5 cm)
Purchased with the Joseph E. Temple Fund
1986-137-1
Pl. 8

26. RAYMOND GALLUCCI
American, born 1923
Vase, 1969
Stoneware, partially glazed
Height 18 inches (45.7 cm)
Gift of students of the artist and Mrs. David H. Lehman
1970-84-1*

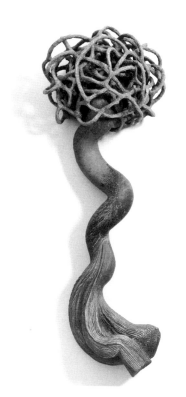

12

14

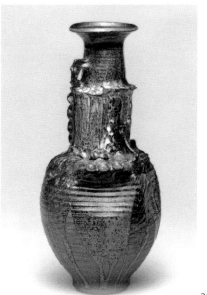

26

27. DAVID GILHOOLY
American, born 1943
Osiris Vegefrogged, 1973
Earthenware, glazed
Height 13¾ inches (34.9 cm)
Purchased with the Bloomfield Moore Fund
1974-79-1
Pl. 9

28. WAYNE HIGBY
American, born 1943
Big Basin Pass, 1976
Earthenware, raku-fired and glazed
Height 12 inches (30.5 cm)
Gift of Collab: The Group for Modern and Contemporary
Design at the Philadelphia Museum of Art
1976-106-1

29. WAYNE HIGBY
White Granite Bay, 1982
Earthenware, raku-fired and glazed
Height approximately 12 inches (30.5 cm) each
Gift of Mrs. Robert L. McNeil, Jr.
2001-23-1–4
Pl. 10

30. WAYNE HIGBY
Frozen Day Mesa, 1984
Earthenware, raku-fired and glazed
Height 12½ inches (31.8 cm)
Promised gift of Harvey S. Shipley Miller and
J. Randall Plummer
Pl. 11

31. WAYNE HIGBY
Idolon Bay, 1986
Earthenware, raku-fired and glazed
Height 11 inches (27.9 cm)
Gift of The Women's Committee of the Philadelphia
Museum of Art
1992-5-2

32. THOMAS A. HOADLEY
American, born 1949
Nerikomi Vessel, 1992
Porcelain, unglazed
Height 12 inches (30.5 cm)
Gift of The Women's Committee of the Philadelphia
Museum of Art
1992-109-2*

33. GEORGE JOHNSON
American, born 1951
Tiger Bowl, 1998
Stoneware, glazed
Height 5¼ inches (13.3 cm)
Gift of The Women's Committee of the Philadelphia
Museum of Art
1998-10-3

34. GEORGE JOHNSON
Olive Oropendola on Bucket, 2001
Stoneware, glazed
Height 19½ inches (49.5 cm)
Gift of The Women's Committee of the Philadelphia
Museum of Art
2002-8-1*

35. JUN KANEKO
American, born Japan, 1942
Plate with Cloth Wrapper, 1982
Stoneware, glazed, and cotton
12 x 9¾ inches (30.5 x 24.8 cm)
Gift of the Friends of the Philadelphia Museum of Art
1982-92-1

36. JUN KANEKO
Plate, 1984
Stoneware, glazed
Width 20 inches (50.8 cm)
Gift of Marion Boulton Stroud
1984-101-1
Pl. 12

37. KAREN KARNES
American, born 1925
Covered Jar, 1980
Stoneware, glazed
Height 11¾ inches (29.8 cm)
Gift of The Women's Committee of the Philadelphia
Museum of Art
1981-38-1a, b

38. KAREN KARNES
Covered Casserole, 1986
Stoneware, glazed
Height 16½ inches (41.9 cm)
Gift of The Women's Committee of the Philadelphia
Museum of Art
1986-104-2a, b*

39. MICHAEL LUCERO
American, born 1953
Rock Garden Dreamer, 1984
Earthenware, glazed
Width 24 inches (61 cm)
Gift of Charles W. Nichols
2001-199-1
Pl. 13

40. PHILLIP MABERRY
American, born 1951
Bowl on Tripod, 1983
Porcelain, glazed, with metal tripod
Height 15 inches (38.1 cm)
Gift of Helene Margolies Rosenbloom in memory
of Leon Rosenbloom
1983-170-1a, b*

41. WARREN MacKENZIE
American, born 1924
Tea Bowl, 1992
Stoneware, glazed
Diameter 4½ inches (11.4 cm)
Gift of Jeanne and John Driscoll
1992-105-1

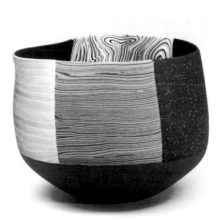

32

34

38

42. WARREN MacKENZIE
Drop-Rim Bowl, 1997
Stoneware, glazed
Diameter 10¼ inches (26 cm)
Purchased with the Gertrude Schemm Binder Fund
1997-151-1

43. WARREN MacKENZIE
Vase, 1997
Stoneware, glazed
Height 13¼ inches (33.7 cm)
Purchased with the Gertrude Schemm Binder Fund
1997-151-2

44. JAMES MAKINS
American, born 1946
Sugar Bowl and Creamer, 1984
Porcelain, glazed
Height (creamer) 6⅞ inches (17.5 cm);
(sugar bowl) 5 inches (12.7 cm)
Gift of The Women's Committee of the Philadelphia
Museum of Art
1984-24-1, 2

45. JAMES MAKINS
Six-Piece Coffee and Tea Service, c. 1980s
Porcelain, glazed
Height (coffee pot) 9⅜ inches (23.8 cm); (teapot)
6 inches (15.2 cm); (sugar bowl) 5 inches (12.7 cm);
(creamer) 6⅞ inches (17.5 cm); (cups) 3⅜ inches
(8.6 cm); diameter (saucers) approximately 6 inches
(15.2 cm)
Gift of Mr. and Mrs. Jack R. Bershad
1997-53-1–6*

46. MARIA MARTINEZ
American, 1881–1985
Bowl, c. 1923
Earthenware, glazed
Diameter 9 inches (22.9 cm)
Gift of Mr. and Mrs. J. Welles Henderson
1994-90-1

47. KARL MARTZ
American, 1912–1997
Bowl, 1978
Stoneware, glazed
Diameter 6½ inches (16.5 cm)
Gift of Frederick James Kent in memory of
John R. Angell
1986-103-3

48. RON NAGLE
American, born 1939
Untitled, 1981
Earthenware, glazed and painted
Height 6 inches (15.2 cm)
Gift of The Women's Committee of the Philadelphia
Museum of Art
1981-38-2
Pl. 14

49. GERTRUD NATZLER
American, born Austria, 1908–1971
OTTO NATZLER
American, born Austria, 1908
Plate, 1941
Earthenware, glazed (white ornamental glaze)
Diameter 12 inches (30.5 cm)
Gift of Mrs. Herbert Cameron Morris
1945-68-3
Pl. 16

50. GERTRUD and OTTO NATZLER
Vase, 1943
Earthenware, glazed (silvergreen glaze)
Height 5¾ inches (14.6 cm)
Gift of Mrs. Herbert Cameron Morris
1945-68-4

51. GERTRUD and OTTO NATZLER
Bowl, 1945
Earthenware, glazed (Pompeian earth glaze)
Diameter 13¾ inches (34.9 cm)
Gift of Mrs. Herbert Cameron Morris
1945-68-2

52. GERTRUD and OTTO NATZLER
Vase, 1945
Earthenware, glazed (vert de lune glaze)
Height 5¾ inches (14.6 cm)
Gift of Mrs. Herbert Cameron Morris
1945-68-1

53. GERTRUD and OTTO NATZLER
Bowl, 1946
Earthenware, glazed (green Pompeian lava glaze)
Diameter 9½ inches (24.1 cm)
The Louis E. Stern Collection
1963-181-190
Pl. 15

54. GERTRUD and OTTO NATZLER
Bowl, 1946
Earthenware, glazed (dusk reduction glaze)
Diameter 5¾ inches (14.6 cm)
The Louis E. Stern Collection
1963-181-191

55. GERTRUD and OTTO NATZLER
Bowl, 1946
Earthenware, glazed (tiger eye reduction glaze)
Diameter 4⁷⁄₁₆ inches (11.3 cm)
The Louis E. Stern Collection
1963-181-192

56. GERTRUD and OTTO NATZLER
Bottle, 1957
Earthenware, glazed (sang nocturne reduction glaze)
Height 17⅜ inches (44.1 cm)
The Louis E. Stern Collection
1963-181-193
Pl. 17

40

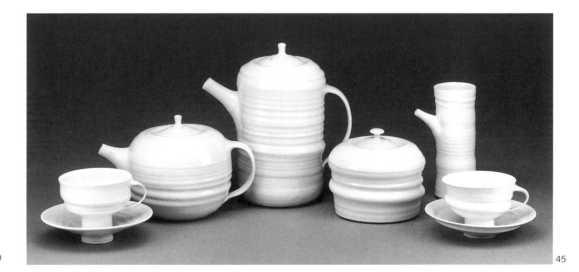

45

57. GERTRUD and OTTO NATZLER
Vase, 1962
Earthenware, glazed (dark red glaze)
Height 8½ inches (21.6 cm)
Gift of The Women's Committee of the Philadelphia
Museum of Art
1985-78-1
Pl. 18

58. GEORGE OHR
American, 1857–1918
Vase, c. 1910
Earthenware, glazed
Height 7 inches (17.8 cm)
Gift of the Friends of the Philadelphia Museum of Art
1994-5-3*

59. WILLIAM PARRY
American, born 1918
Anima Mundi, 1965
Stoneware with applied color
Height 30 inches (76.2 cm)
Gift of the artist
1997-70-1*

60. WILLIAM PARRY
KFS (Knife, Fork, Spoon) II, c. 1982
Stoneware with applied color
Length (knife) 22 inches (55.9 cm); (fork)
24 inches (61 cm); (spoon) 24 inches (61 cm)
Gift of the artist
1995-77-1a–c
Pl. 19

61. WILLIAM PARRY
Ob (Off Butterfly) 24, 1986
Stoneware with applied color
Height 17 inches (43.2 cm)
Gift of the artist
1995-77-2

62. KENNETH PRICE
American, born 1935
Untitled, 1981
Porcelain, glazed and painted
Height 10 inches (25.4 cm)
Gift of The Women's Committee of the Philadelphia
Museum of Art
1981-38-3
Pl. 20

63. KENNETH PRICE
Grauman's, 1988
Whiteware, glazed and painted
Height 9 inches (22.9 cm)
Gift of The Women's Committee of the Philadelphia
Museum of Art
1989-20-3
Pl. 21

64. DONALD L. REITZ
American, born 1929
Covered Jar, c. 1970
Stoneware, glazed
Height 8½ inches (21.6 cm)
Gift of Frederick James Kent in memory of
John R. Angell
1986-103-4a, b*

65. GLADYS LLOYD ROBINSON
American, 1896–1971
Jewel Box, 1951
Stoneware, glazed
Height 6¾ inches (17.1 cm)
Gift of Emma Feldman in memory of her brother,
Samuel Feldman
1951-116-1a, b

66. MARY SCHEIER
American, born 1909
EDWIN SCHEIER
American, born 1910
Bowl, 1958
Stoneware, glazed
Diameter 9¼ inches (23.5 cm)
Gift of The Women's Committee of the Philadelphia
Museum of Art
1985-78-2*

67. MARY and EDWIN SCHEIER
Bowl, c. 1958
Stoneware, glazed
Diameter 14 inches (35.6 cm)
Gift in memory of Eugene Sussel by his wife,
Charlene Sussel
1991-98-87

68. DAVID SHANER
American, 1934–2002
Pillow, n.d.
Stoneware with applied color
Diameter 11½ inches (29.2 cm)
Gift of Mrs. Robert L. McNeil, Jr.
1992-18-3

69. RICHARD SHAW
American, born 1941
Walking Skeleton, 1980
Porcelain, glazed
Height 31½ inches (80 cm)
Gift of The Women's Committee of the Philadelphia
Museum of Art
1981-38-4
Pl. 22

58

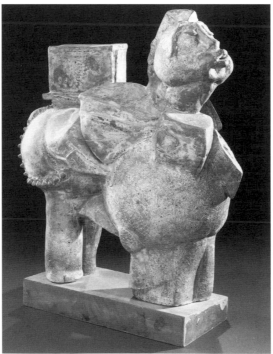

59

64

70. ROB SIEMINSKI
American, born 1953
Ceramic Centerpiece, c. 1980–85
Clay, raku-fired, with nails and river rocks
Height 11 inches (27.9 cm)
Gift of Mrs. Robert L. McNeil, Jr.
1997-10-1*

71. PAUL SOLDNER
American, born 1921
Vase, 1972
Earthenware, raku-fired
Height 18 inches (45.7 cm)
Gift of J. Welles and Hannah L. Henderson
1996-172-1
Pl. 23

72. PAUL SOLDNER
Vase, 1972
Earthenware, raku-fired
Height 10 inches (25.4 cm)
Gift of J. Welles and Hannah L. Henderson
1996-172-2

73. RUDOLF STAFFEL
American, 1911–2002
Head, 1938
Stoneware, glazed
Height 8⅜ inches (21.3 cm)
Purchased with funds contributed by Daniel W. Dietrich,
Henry S. McNeil, Jr., Betty Gottlieb, Frances and Bayard
Storey, Robert Tooey and Vicente Lim, June and Perry
Ottenberg, and The Acorn Club, and gift of Helen
Williams Drutt English in honor of the artist
2001-109-1
Pl. 24

74. RUDOLF STAFFEL
Plate, 1947
Earthenware, glazed
Diameter 11 inches (27.9 cm)
Gift of the artist
1995-146-1

75. RUDOLF STAFFEL
Plate, 1947
Earthenware, glazed
Diameter 12 inches (30.5 cm)
Gift of the artist
1996-178-1

76. RUDOLF STAFFEL
Bowl, 1960
Stoneware, glazed
Diameter 13½ inches (34.3 cm)
Gift of Helen Williams Drutt
1976-167-1*

77. RUDOLF STAFFEL
Bowl, 1966
Porcelain, unglazed
Diameter 6¾ inches (17.1 cm)
Gift of Helen Williams Drutt
1970-87-1

78. RUDOLF STAFFEL
Bowl, 1969
Porcelain, unglazed
Diameter 9½ inches (24.1 cm)
Gift of the Philadelphia Chapter, National Home
Fashions League, Inc.
1970-86-3
Pl. 25

79. RUDOLF STAFFEL
Vase, 1969–70
Porcelain, glazed
Height 9½ inches (24.1 cm)
Gift of the Philadelphia Chapter, National Home
Fashions League, Inc.
1970-86-4

80. RUDOLF STAFFEL
Vase, 1969–70
Porcelain, unglazed, washed with copper salts
Height 6¼ inches (15.9 cm)
Gift of the Philadelphia Chapter, National Home
Fashions League, Inc.
1970-86-5

81. RUDOLF STAFFEL
Vase, 1969–70
Porcelain, unglazed, washed with copper salts
Height 6¾ inches (17.1 cm)
Gift of the Philadelphia Chapter, National Home
Fashions League, Inc.
1970-86-6

82. RUDOLF STAFFEL
Vase, 1973
Porcelain, unglazed, washed with copper salts
Height 8⅞ inches (22.5 cm)
Gift of Dr. and Mrs. Perry Ottenberg
1991-161-3
Pl. 27

83. RUDOLF STAFFEL
"Painted" Vase, c. 1973
Porcelain, stained and glazed
Height 11½ inches (29.2 cm)
Gift of Dr. and Mrs. Perry Ottenberg
1991-161-4

84. RUDOLF STAFFEL
Light Gatherer, 1975
Porcelain with glazed elements
Height 3³⁄₁₆ inches (8.1 cm)
Gift of Mrs. Robert L. McNeil, Jr.
1998-83-5

85. RUDOLF STAFFEL
Plate, 1975
Porcelain, glazed, with slip decoration
Diameter 11½ inches (29.2 cm)
Gift of Dr. and Mrs. Perry Ottenberg
1991-161-1

86. RUDOLF STAFFEL
Face Vase, c. 1975
Porcelain with glazed elements
Height 9 inches (22.9 cm)
Gift of Dr. and Mrs. Perry Ottenberg
1991-161-2

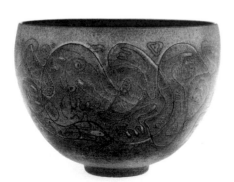

66

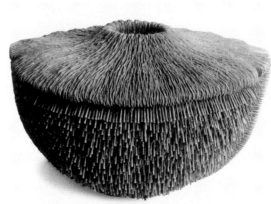

70

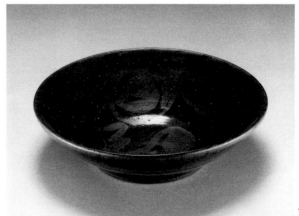

76

87. RUDOLF STAFFEL
"Writing" Vase, c. 1975
Porcelain, unglazed and stained
Height 10¼ inches (26 cm)
Gift of Dr. and Mrs. Perry Ottenberg
1991-161-5

88. RUDOLF STAFFEL
Vase, c. 1979–80
Terra cotta with gold luster glaze
Height 10½ inches (26.7 cm)
Gift of The Women's Committee of the Philadelphia
Museum of Art
1995-81-4*

89. RUDOLF STAFFEL
Light Gatherer, 1981
Porcelain, unglazed, washed with copper salts
Height 10 inches (25.4 cm)
Gift of The Women's Committee of the Philadelphia
Museum of Art
1985-30-1

90. RUDOLF STAFFEL
Light Gatherer, 1981
Porcelain, partially glazed
Diameter 6¼ inches (15.9 cm)
Purchased with funds contributed by The Women's
Committee of the Philadelphia Museum of Art
1997-65-1
Pl. 26

91. RUDOLF STAFFEL
Light Gatherer, c. 1985
Porcelain, unglazed and colored
Diameter 12 inches (30.5 cm)
Gift of Margaret Chew Dolan and Peter Maxwell
2001-191-1

92. RUDOLF STAFFEL
Small Light Gatherer, c. 1989
Porcelain
Diameter 3¾ inches (9.5 cm)
Gift of Mrs. Richard Jacobs
1998-158-1

93. RUDOLF STAFFEL
Light Gatherer, n.d.
Porcelain, stained
Diameter 9⅝ inches (24.4 cm)
Gift of June and Perry Ottenberg in honor of the Friends
of the Philadelphia Museum of Art
1995-144-1

94. RUDOLF STAFFEL
Chalice, n.d.
Porcelain, stained
Height 6½ inches (16.5 cm)
Gift of June and Perry Ottenberg in honor of the Friends
of the Philadelphia Museum of Art
1995-144-2

95. RUDOLF STAFFEL
Light Gatherer, n.d.
Porcelain
Height 6½ inches (16.5 cm)
Gift of June and Perry Ottenberg in honor of the Friends
of the Philadelphia Museum of Art
1995-144-3

96. RUDOLF STAFFEL
Bowl, n.d.
Porcelain, glazed
Diameter 6¼ inches (15.9 cm)
Gift of June and Perry Ottenberg in honor of the Friends
of the Philadelphia Museum of Art
1995-144-4

97. RUDOLF STAFFEL
Light Gatherer, n.d.
Porcelain, glazed
Height 7¾ inches (19.7 cm)
Gift of June and Perry Ottenberg in honor of the Friends
of the Philadelphia Museum of Art
1995-144-5

98. RUDOLF STAFFEL
Light Gatherer, n.d.
Porcelain, glazed
Height 5¼ inches (13.3 cm)
Gift of June and Perry Ottenberg in honor of the Friends
of the Philadelphia Museum of Art
1995-144-6

99. RUDOLF STAFFEL
Light Gatherer, n.d.
Porcelain, unglazed
Diameter 7⅝ inches (19.4 cm)
Gift of June and Perry Ottenberg in honor of the Friends
of the Philadelphia Museum of Art
1995-144-7

100. RUDOLF STAFFEL
Bowl, n.d.
Porcelain, stained
Diameter 8¾ inches (22.2 cm)
Gift of June and Perry Ottenberg in honor of the Friends
of the Philadelphia Museum of Art
1995-144-8

101. LIZBETH STEWART
American, born 1948
Fly, 1982
Porcelain, glazed
Height 14 inches (35.6 cm)
Gift of Mr. and Mrs. Paul M. Ingersoll
1982-25-1*

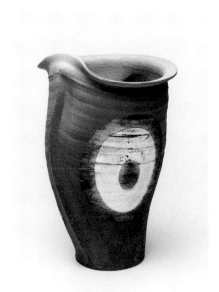
88

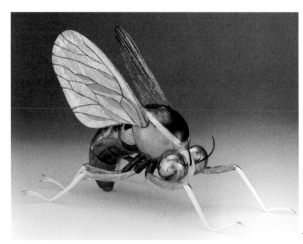
101

102. TOSHIKO TAKAEZU
American, born 1922
Ceramic Form, c. 1980
Porcelain, glazed
Height 7¾ inches (19.7 cm)
Gift of Mrs. Robert L. McNeil, Jr.
1997-10-4*

103. TOSHIKO TAKAEZU
Pair of Mauve Forms, 1984
Porcelain, glazed
Height (1984-103-1) 16½ inches (41.9 cm);
(1984-103-2) 13½ inches (34.3 cm)
Gift of The Women's Committee of the Philadelphia
Museum of Art
1984-103-1, 2

104. TOSHIKO TAKAEZU
Form, 1990
Stoneware, glazed
Height 45 inches (114.3 cm)
Gift of The Women's Committee of the Philadelphia
Museum of Art
1992-109-3
Pl. 28

105. ROBERT TURNER
American, born 1913
Covered Jar, c. 1964–65
Stoneware, glazed
Height 12 inches (30.5 cm)
Purchased with funds contributed by The Women's
Committee of the Philadelphia Museum of Art, and gift
of the artist courtesy of Helen Drutt: Philadelphia
1999-115-1a, b

106. ROBERT TURNER
Form #1, 1980
Stoneware, glazed
Height 9⅜ inches (23.8 cm)
Gift of The Women's Committee of the Philadelphia
Museum of Art
1981-38-5a, b
Pl. 31

107. ROBERT TURNER
Hi Square, 1984
Stoneware, glazed
Height 11 inches (27.9 cm)
Gift of The Women's Committee of the Philadelphia
Museum of Art
1992-5-3
Pl. 30

108. ROBERT TURNER
Covered Jar, 1995
Stoneware, glazed
Height 16 inches (40.6 cm)
Gift of the artist courtesy of Helen Drutt: Philadelphia
1999-60-1a, b
Pl. 29

109. KENNETH VAVREK
American, born 1939
Lover's Leap, 1997–98
Stoneware, glazed
Height 72 inches (182.9 cm)
Gift of the artist
1999-61-1

110. PETER VOULKOS
American, 1924–2002
Vase, 1977
Stoneware, unglazed
Height 34 inches (86.4 cm)
Gift of The Women's Committee of the Philadelphia
Museum of Art
1989-20-4
Pl. 32

111. PAULA WINOKUR
American, born 1935
Birdbath, 1969
Stoneware, unglazed
Height 14½ inches (36.8 cm)
Gift of the Philadelphia Chapter, National Home
Fashions League, Inc.
1970-86-1*

112. PAULA WINOKUR
Governor's Award (Presented to R. M. Scott), 1996
Porcelain, unglazed
Height 21½ inches (54.6 cm)
Gift of Robert Montgomery Scott
1996-176-2

113. ROBERT WINOKUR
American, born 1933
Cookie Jar with Lid, 1972
Stoneware, glazed
Height 9½ inches (24.1 cm)
Gift of Rudolf H. Staffel
1973-102-1a, b
Pl. 33

114. ROBERT WINOKUR
Jar with Handle, 1975
Stoneware, salt-glazed
Height 16¾ inches (42.5 cm)
Purchased with the Elizabeth Wandell Smith Fund
1982-69-1
Pl. 34

115. ROBERT WINOKUR
Pitcher, n.d.
Stoneware, glazed
Height 14 inches (35.6 cm)
Gift of Helen Williams Drutt English in memory
of Peter Dormer
1996-171-2

116. BEATRICE WOOD
American, 1893–1998
Vase, 1940
Earthenware, glazed
Height 4 inches (10.2 cm)
Gift of the Francis Bacon Foundation
1996-3-1

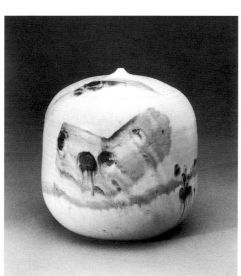

102

111

117. BEATRICE WOOD
Bowl, 1948–50
Earthenware, luster-glazed
Diameter 8½ inches (21.6 cm)
Gift of The Women's Committee of the Philadelphia
Museum of Art
1984-24-4
Pl. 35

118. BEATRICE WOOD
Clytemnestra and Iphigenia (Two Cats), c. 1950
Earthenware, glazed
Height (Clytemnestra) 10 inches (25.4 cm);
(Iphigenia) 7¾ inches (19.7 cm)
Gift of the artist
1994-101-1, 2
Pl. 37

119. BEATRICE WOOD
Love Boat Tureen, 1993
Earthenware, glazed
Height 15 inches (38.1 cm)
Bequest of Edna S. Beron
1996-2-13a, b*

120. BEATRICE WOOD
Bowl, n.d.
Earthenware, luster-glazed
Height 8 inches (20.3 cm)
Gift of Anne d'Harnoncourt Rishel in honor of
the artist's 100th birthday
1993-47-1

121. BEATRICE WOOD
Chalice, n.d.
Earthenware, luster-glazed
Height 12 inches (30.5 cm)
Gift of Mrs. Robert L. McNeil, Jr.
1992-18-2
Pl. 36

122. BETTY WOODMAN
American, born 1930
Persian Silk Pillow Pitcher, 1982
Earthenware, glazed
Height 19 inches (48.3 cm)
Gift of Marion Boulton Stroud
1988-90-1
Pl. 38

123. BETTY WOODMAN
Diptych Vases, "Orpheus," c. 1991
Earthenware, partially glazed
Height (1993-80-1a) 25 inches (63.5 cm);
(1993-80-1b) 24 inches (61 cm)
Gift of Jocelyn and Charles Woodman
1993-80-1a, b

124. BETTY WOODMAN
Spring Outing, 2000
Earthenware, glazed, with epoxy resin, lacquer, and paint
Height approximately 38 inches (96.5 cm) each
Gift of The Women's Committee of the Philadelphia
Museum of Art
2001-16-1a–c
Pl. 39

125. WILLIAM WYMAN
American, 1922–1980
Untitled, 1977
Stoneware, glazed
Height 22¼ inches (56.5 cm)
Gift of Marilyn Pappas
1991-105-1

FIBER

126. YVONNE PACANOVSKY BOBROWICZ
American, born 1928
Energy Field, 1989
Monofilament and gold leaf
Height 90 inches (228.6 cm)
Purchased with the Julius Bloch Memorial Fund
created by Benjamin D. Bernstein
1990-45-1*

127. ROBERT BRADY
American, born 1946
San Miguel, 1962
Wool and cotton
72 × 47 inches (182.9 × 119.4 cm)
Gift of Mrs. Eugénie Prendergast
1964-104-3

128. LOUISE TODD COPE
American, born 1930
Hanging, 1996
Silk, cotton, and mirror glass
84 × 84 inches (213.4 × 213.4 cm)
Gift of Helen Williams Drutt English
1998-92-1

129. JUNE GROFF
American, 1903–1974
Fabric, 1947
Linen
156 × 54 inches (396.2 × 137.2 cm)
Gift of the artist
P'1948-13-1*

130. JUNE GROFF
American, 1903–1974
Fabric, 1947
Linen
124½ × 54 inches (316.2 × 137.2 cm)
Gift of the artist
P'1948-13-2

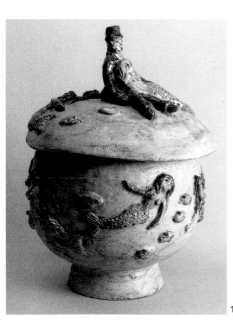

119

126

129

131. JUNE GROFF
Fabric, 1947
Linen
118 × 57 inches (299.7 × 144.8 cm)
Gift of the artist
P'1948-13-3

132. JUNE GROFF
Fabric, 1947
Linen
172 × 44 inches (436.9 × 111.8 cm)
Gift of the artist
P'1948-13-4

133. H. THEODORE HALLMAN, JR.
American, born 1933
L'Égyptien, 1965
Acrylic, linen, wool, cotton, and metal rods
87 × 52 inches (221 × 132.1 cm)
Gift of the artist
1975-3-1*

134. H. THEODORE HALLMAN, JR.
Woven Textile, n.d.
Wool
Length 108 inches (274.3 cm)
Gift of the artist and Helen Williams Drutt English
1993-92-1

135. NANCY HERMAN
American, born 1939
Mystic Blue, 1980
Cotton
58 × 58 inches (147.3 × 147.3 cm)
Gift of the artist
2000-10-1

136. SHEILA HICKS
American, born 1934
Grand Prayer Rug, 1964
Wool and cotton
144 × 60 inches (365.8 × 152.4 cm)
Gift of The Women's Committee of the Philadelphia
Museum of Art
1994-80-1
Pl. 41

137. SHEILA HICKS
"Badagara" Fabric, designed 1968
Cotton
183 × 119½ inches (464.8 × 303.5 cm)
Gift of the artist
1994-110-1

138. SHEILA HICKS
Prayer Rug, c. 1974
Wool and camel's hair
72 × 54 inches (182.9 × 137.2 cm)
Gift of the artist
1995-15-2

139. SHEILA HICKS
Miniature Weaving, late 1980s
Silk, cotton, bast fiber, wool, acrylic, synthetic fibers,
plastic, and paper
8⅝ × 4¾ inches (21.9 × 12.1 cm)
Gift of the artist
1995-72-3
Pl. 40

140. SHEILA HICKS
Banisteriopsis—Dark Ink, 1968–94
Linen, wool, and synthetic raffia
Height 71 inches (180.3 cm)
Gift of the artist
1995-72-1
Pl. 42

141. SHEILA HICKS
Tresors et Secrets, 1990–95
Silk, wool, cotton, linen, raffia, and synthetic fiber
Diameter 3–9½ inches (7.6–24.1 cm) each
Gift of the artist
1995-15-1a–bb; 1995-72-2a–qq
Pl. 43

142. BRYANT HOLSENBECK
American, born 1949
Basket, 1979
Supplejack and reed
10½ × 33½ inches (26.7 × 85.1 cm)
Gift of Mrs. Robert L. McNeil, Jr.
1979-101-1

143. DIANE ITTER
American, 1946–1989
Diagonal Slide, 1980
Linen and silk
18 × 14⅛ inches (45.7 × 35.9 cm)
Gift of Mrs. Robert L. McNeil, Jr.
1998-83-10

144. DIANE ITTER
Ombré Corners, 1982
Linen and silk
20 × 16 inches (50.8 × 40.6 cm)
Gift of Mrs. Robert L. McNeil, Jr.
1998-83-11*

145. MARY JACKSON
American, born 1945
Basket, 1988
Sweetgrass
Height 13 inches (33 cm)
Gift of Mrs. Robert L. McNeil, Jr.
1994-22-1*

133

144

145

146. LEWIS KNAUSS
American, born 1947
Last Street in Giza, 1980
Linen, hemp, and acrylic paint
Height 30 inches (76.2 cm)
Gift of Helen Williams Drutt English in memory of
Peter Dormer
1996-171-3

147. LEWIS KNAUSS
Field, 1998
Linen, paper twine, wire, paper, and acrylic paint
Height 22 inches (55.9 cm)
Gift of The Women's Committee of the Philadelphia
Museum of Art in honor of Judith Altman
2000-55-1
Pl. 44

148. RICHARD LANDIS
American, born 1931
Apollo, 1992–93
Cotton
41 × 12 inches (104.1 × 30.5 cm)
Gift of The Women's Committee of the Philadelphia
Museum of Art
1994-100-1
Pl. 45

149. DOROTHY LIEBES
American, 1899–1971
Prototype for a Roller Cloth, c. 1950
Bamboo, chenille, and metallic yarn
22¼ × 46½ inches (56.5 × 118.1 cm)
Gift of Bonnie Cashin
1991-115-29

150. DOROTHY LIEBES
Window Blind, c. 1950
Wood, Lurex, chenille, and yarn
48 × 72 inches (121.9 × 182.9 cm)
Gift of Mrs. Jeanette S. Epstein
1985-97-1

151. DONA LOOK
American, born 1948
Basket #8616, 1986
Birch bark and silk
Height 10½ inches (26.7 cm)
Gift of The Women's Committee of the Philadelphia
Museum of Art
1986-104-3*

152. DONA LOOK
Basket #8613, 1990
White birch bark and silk
Height 10 inches (25.4 cm)
Gift of Mrs. Robert L. McNeil, Jr.
1992-18-4a, b

153. CAROL NEWHARD McMAUGH
American, born 1945
Quilt, 1975–76
Cotton and cotton-polyester
69 × 59 inches (175.3 × 149.9 cm)
Gift of the Oreland Quilters
1977-184-1

154. JOHN McQUEEN
American, born 1943
Untitled Basket #39, 1977
Bark, morning glory vine, and basswood
Height 18½ inches (47 cm)
Gift of The Women's Committee of the Philadelphia
Museum of Art
1977-236-1

155. JOHN McQUEEN
Untitled Basket #53, 1978
Basswood
Height 18¾ inches (47.6 cm)
Gift of Marion Boulton Stroud
1991-106-1
Pl. 47

156. JOHN McQUEEN
Untitled Basket #89, 1979
Spruce roots
Height 8½ inches (21.6 cm)
Gift of Mrs. Robert L. McNeil, Jr.
1993-79-1
Pl. 46

157. JOHN McQUEEN
In the Same Bind (#227), 1991
Spruce bark, elm, and string
Width 48 inches (121.9 cm)
Gift of Mr. and Mrs. Leonard I. Korman
2001-97-1
Pl. 48

158. MARY MERKEL-HESS
American, born 1949
Blue Reed, 1997
Paper and reed
Width 40 inches (101.6 cm)
Gift of The Women's Committee of the Philadelphia
Museum of Art
1998-10-5*

159. MICHAEL OLSZEWSKI
American, born 1950
The Weight of Being, 2000
Silk and wool
13½ × 22 inches (34.3 × 55.9 cm)
Purchased with the Costume and Textiles Revolving Fund
2000-128-1
Pl. 49

160. ED ROSSBACH
American, born 1914
Disintegration of the Bauhaus, 1967
Jute
42 × 70 inches (106.7 × 177.8 cm)
Gift of The Women's Committee of the Philadelphia
Museum of Art
1998-10-1
Pl. 51

151

158

161. ED ROSSBACH
Plaid Ikat, 1968
Silk
105 × 38 inches (266.7 × 96.5 cm)
Gift of The Women's Committee of the Philadelphia
Museum of Art
1998-10-2

162. ED ROSSBACH
Western Red, 1989
Ash splints, rice paper, rags, and rawhide
Height 17 inches (43.2 cm)
Bequest of Edna S. Beron
1996-2-7

163. ED ROSSBACH
Mickey Basket, 1991
Ash splints, rice paper, rags, and rawhide
Height 11 inches (27.9 cm)
Bequest of Edna S. Beron
1996-2-8
Pl. 50

164. SCOTT ROTHSTEIN
American, born 1955
#27, c. 1990
Silk
20 × 35 inches (50.8 × 88.9 cm)
Gift of Dr. Marcia Meckler and Helen Williams Drutt English
1991-124-1

165. JANE SAUER
American, born 1937
Basket Form, c. 1989
Waxed linen thread
Height 12 inches (30.5 cm)
Gift of Mrs. Robert L. McNeil, Jr.
1993-79-2*

166. CYNTHIA SCHIRA
American, born 1934
Canescent Lake, 1989
Cotton, rayon, and mixed fibers
76 × 64 inches (193 × 162.6 cm)
Gift of The Women's Committee of the Philadelphia
Museum of Art
1991-8-2
Pl. 52

167. JOYCE SCOTT
American, born 1948
*Rodney King's Head Was Squashed Like a
Watermelon,* 1991
Beads and thread
Length 10¾ inches (27.3 cm)
Gift of The Women's Committee of the Philadelphia
Museum of Art
1995-81-3
Pl. 53

168. THOMAS STEARNS
American, born 1936
Night Image #1, 1963
Mixed fibers on wooden form
Height 54½ inches (138.4 cm)
Gift of Miani Johnson in memory of her mother,
Marian Willard Johnson
1992-80-1
Pl. 54

169. LENORE TAWNEY
American, born 1907
The Fountain of Word and Water, 1963
Linen
Height 162 inches (411.5 cm)
Gift of The Women's Committee of the Philadelphia
Museum of Art
1994-23-1
Pl. 55

170. EVELYN SVEC WARD
American, 1921–1989
Cadena de Oro, 1968
Burlap, wool, velvet, ribbon, cotton, and mixed fibers
28⅓ × 10¼ inches (72 × 26 cm)
Gift of William E. Ward
1995-21-1
Pl. 56

171. KATHERINE WESTPHAL
American, born 1919
Maize, 1988
Raffia
9 × 6½ inches (22.9 × 16.5 cm)
Bequest of Edna S. Beron
1996-2-12*

172. CLAIRE ZEISLER
American, 1903–1991
Private Affair II, 1986
Cotton and rayon
Height 120 inches (304.8 cm)
Gift of The Women's Committee of the Philadelphia
Museum of Art
1987-49-2
Pl. 57

FURNITURE

173. WENDELL CASTLE
American, born 1932
Music Stand, 1972
Cherry
Height 46½ inches (118.1 cm)
Gift of the Friends of the Philadelphia Museum of Art
1973-94-1
Pl. 59

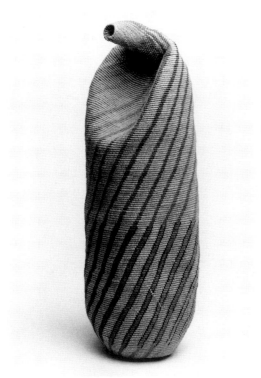

165

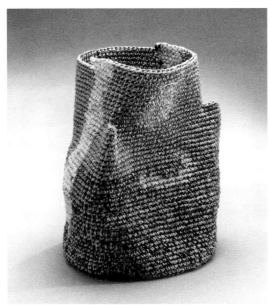

171

174. WENDELL CASTLE
Molar Chair, 1973
Glass-reinforced polyester
Height 26 inches (66 cm)
Gift of the artist
1973-99-1

175. WENDELL CASTLE
Table with Gloves and Keys, 1980
Mahogany
Height 34½ inches (87.6 cm)
Gift of Mrs. Robert L. McNeil, Jr.
2001-15-1
Pl. 58

176. WENDELL CASTLE
Looking Glass, 1982
Mahogany and glass
Height 30¼ inches (76.8 cm)
Gift of Mrs. Robert L. McNeil, Jr.
2001-15-2

177. WENDELL CASTLE
Ladder of Eurus, 1986
Purpleheart, curly maple, and ebony veneer
Height 65 inches (165.1 cm)
Gift of The Women's Committee of the Philadelphia
Museum of Art
1986-104-1
Pl. 60

178. JOHN CEDERQUIST
American, born 1946
Steamer (Cabinet), 2001
Various woods, stained
Height 70 inches (177.8 cm)
Gift of The Women's Committee of the Philadelphia
Museum of Art and Franklin Parrasch
2001-17-1
Pl. 61

179. WHARTON ESHERICK
American, 1887–1970
*Steps for the Music Room with Elephant and Donkey
Finials,* 1935
From the Curtis Bok House, Gulph Mills, Pennsylvania
Hickory
Height 35 inches (88.9 cm)
Gift of Rachel Bok Goldman and Allen S. Goldman, M.D.
2001-14-1
Pl. 63

180. WHARTON ESHERICK
Fireplace and Doorway, 1936–37
From the library and music room of the Curtis Bok House,
Gulph Mills, Pennsylvania
White oak, stone, copper, and brass
102 × 192 × 60 inches (259.1 × 487.7 × 152.4 cm)
Acquired through the generosity of W. B. Dixon Stroud,
with additional funds for its preservation and installation
provided by Dr. and Mrs. Allen Goldman, Marion Boulton
Stroud, and The Women's Committee of the Philadelphia
Museum of Art
1989-1-1, 2
Pl. 64

181. WHARTON ESHERICK
*Two Upholstered Armless Settees and One Phonograph
Cabinet,* 1936–37
From the music room of the Curtis Bok House,
Gulph Mills, Pennsylvania
Hand-carved oak frame with upholstered seat and back
(settees); cherry (phonograph cabinet)
Width (larger settee) 83½ inches (212.1 cm); (smaller
settee) 53½ inches (135.9 cm); height (phonograph
cabinet) 27½ inches (69.9 cm)
Partial and promised gift of Enid Curtis Bok Okun,
daughter of Curtis and Nellie Lee Bok
2001-201-1–3
Pl. 62 (phonograph cabinet)

182. WHARTON ESHERICK
Upholstered Chairs, 1936–37
From the library and music room of the Curtis Bok House,
Gulph Mills, Pennsylvania
Height (larger chair) 34 inches (86.4 cm);
(smaller chair) 31 inches (78.7 cm)
Gift of Rachel Bok Goldman
2000-49-1, 2

183. WHARTON ESHERICK
Blackboard, 1942–44
Walnut
Length 67½ inches (171.5 cm)
Gift of Schutte and Koerting Co.
1971-205-18

184. WHARTON ESHERICK
*Board Room Table, Twelve Side Chairs, and Two
Armchairs,* 1942–44
Walnut and leather
Height (table) 29½ inches (74.9 cm); (side chairs)
34⅞ inches (88.6 cm); (armchairs) 34¾ inches (88.3 cm)
Gift of Schutte and Koerting Co.
1971-205-1–15

185. WHARTON ESHERICK
Desk and Wastepaper Basket, 1942–44
Walnut
Height (desk) 28⅛ inches (71.4 cm);
(basket) 15⅝ inches (39.7 cm)
Gift of Schutte and Koerting Co.
1971-205-16, 17

186. WHARTON ESHERICK
Cabinet, 1961
Walnut and rosewood
Height 100½ inches (255.3 cm)
Gift of Dr. and Mrs. Paul Todd Makler
1965-135-1a, b

187

189

187. DANIEL JACKSON
American, 1938–1995
Leda, the Devil, and the Moon (Looking Glass), 1973
Rosewood, osage orange, and lauan plywood
Height 30 inches (76.2 cm)
Gift of the Friends of the Philadelphia Museum of Art
1973-94-3*

188. JAMES KRENOV
American, born Russia, 1920
Cabinet, 1992
Kwila and spalted hickory
Height 61 inches (154.9 cm)
Gift of The Women's Committee of the Philadelphia
Museum of Art
1992-21-1
Pl. 65

189. JACK LARIMORE
American, born 1950
Walking Vessel, 1993
Cherry, aniline dye, and acrylic lacquer
Height 35½ inches (90.2 cm)
Gift of Lee Osterman and Elissa Topol
1994-21-1*

190. SAM MALOOF
American, born 1916
Rocking Chair, 1977
Walnut
Height 46 inches (116.8 cm)
Gift of Mrs. Robert L. McNeil, Jr.
1992-18-1
Pl. 67

191. SAM MALOOF
Settee, 1991
Fiddleback maple
Height 30 inches (76.2 cm)
Gift of The Women's Committee of the Philadelphia
Museum of Art in commemoration of the Fifteenth
Anniversary of the Philadelphia Craft Show
1991-100-1
Pl. 66

192. WENDY MARUYAMA
American, born 1952
Red Cabinet, 1990
Polychromed poplar and maple
Height 71½ inches (181.6 cm)
Gift of Mr. and Mrs. Leonard I. Korman
2001-97-2
Pl. 68

193. JUDY KENSLEY McKIE
American, born 1944
Panther Bench, 1982
Bronze
Height 27 inches (68.6 cm)
Gift of The Women's Committee of the Philadelphia
Museum of Art
1993-33-1
Pl. 69

194. GEORGE NAKASHIMA
American, 1905–1990
Side Chair, designed 1942, fabricated 1946
Walnut and grass
Height 28¾ inches (73 cm)
Gift of Anne d'Harnoncourt
2001-20-1

195. GEORGE NAKASHIMA
Chair, c. 1945
Walnut
Height 30 inches (76.2 cm)
Gift of Anne d'Harnoncourt in honor of The Women's
Committee of the Philadelphia Museum of Art on
the occasion of the Fifteenth Anniversary of the
Philadelphia Craft Show
1991-102-1
Pl. 71

196. GEORGE NAKASHIMA
"Mira" Chairs, designed 1952
Walnut
Height 27½ inches (69.9 cm)
Gift of Mildred Constantine
1995-68-1, 2
Pl. 72 (1995-68-1)

197. GEORGE NAKASHIMA
Dining Room Table, 1957
Walnut
Height 26½ inches (67.3 cm)
Gift of Mr. and Mrs. William H. Helfand
1978-152-1

198. GEORGE NAKASHIMA
Coffee Table, 1960
Walnut
Height 12 inches (30.5 cm)
Gift of Melvin Schwartz
1993-133-1
Pl. 70

199. TIMOTHY PHILBRICK
American, born 1952
Asymmetrical Table, 1996
Curly cherry
Height 30½ inches (77.5 cm)
Gift of Dr. and Mrs. Joseph A. Chazan
1997-54-1*

200. ROBERT WHITLEY
American, born 1924
Continuum Chair, 1978
Bird's-eye maple
Height 36 inches (91.4 cm)
Gift of Jack and Marlene Udell
1984-122-1*

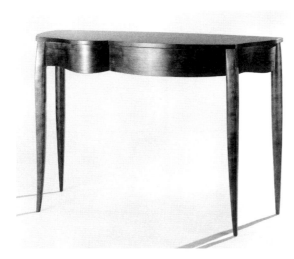

199

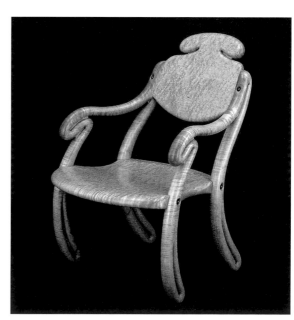

200

293. OLAF SKOOGFORS
Weeders Trophy, 1958
Silver
Height 9¾ inches (24.8 cm)
Gift of the Weeders Garden Club, Pennsylvania
1979-113-1

294. OLAF SKOOGFORS
Decanter, 1966
Silver and rosewood
Height 13¾ inches (34.9 cm)
Gift of the Friends of the Philadelphia Museum of Art
1968-2-1a, b
Pl. 91

WOOD

295. DAVID ELLSWORTH
American, born 1944
Vessel, 1989
Redwood burl
Height 16 inches (40.6 cm)
Gift of The Women's Committee of the Philadelphia
Museum of Art
1989-20-2
Pl. 94

296. RON KENT
American, born 1931
Bowl, n.d.
Norfolk Island pine
Diameter 15¾ inches (40 cm)
Gift of the artist and Helen Drutt: Philadelphia
2001-192-1

297. GYÖNGY LAKY
American, born Hungary, 1944
Evening, 1995
Sycamore
Height 21 inches (53.3 cm)
Gift of The Women's Committee of the Philadelphia
Museum of Art
1998-10-4
Pl. 95

298. MARK LINDQUIST
American, born 1949
Unsung Bowl #4, 1982
Spalted maple
Diameter 18 inches (45.7 cm)
Gift of The Women's Committee of the Philadelphia
Museum of Art
1982-70-1
Pl. 96

299. EDWARD MOULTHROP
American, born 1916
Figured Ellipsoid, c. 1980
Tulipwood
Height 12 inches (30.5 cm)
Gift of Mrs. Robert L. McNeil, Jr.
1997-10-3
Pl. 97

300. PHILIP MOULTHROP
American, born 1947
Bowl, c. 1985
Ash-leaf maple
Diameter 10¼ inches (26 cm)
Gift of Mrs. Robert L. McNeil, Jr.
1997-10-2

301. PETER PIEROBON
American, born 1957
Wistful Words, 1993
Ebonized mahogany
Diameter 36 inches (91.4 cm)
Gift of an anonymous donor
1994-88-1*

302. JAMES PRESTINI
American, 1908–1993
Bowl #3, 1945
Mexican mahogany
Diameter 14⅝ inches (37.1 cm)
Gift of the artist
1979-167-6

303. JAMES PRESTINI
Bowl #65, 1945
Black walnut
Diameter 9¼ inches (23.5 cm)
Gift of the artist
1979-167-11

304. JAMES PRESTINI
Bowl #178, 1945
Mexican mahogany
Diameter 5⅛₁₆ inches (12.9 cm)
Gift of the artist
1979-167-2

305. JAMES PRESTINI
Bowl #35, 1946
Ebonized ash
Diameter 9⅞ inches (25.1 cm)
Gift of the artist
1979-167-9
Pl. 98

306. JAMES PRESTINI
Bowl #55, 1946
Cherry
Diameter 5⅜ inches (13.7 cm)
Gift of the artist
1979-167-3

307. JAMES PRESTINI
Bowl #107, 1947
Curly birch
Diameter 10⁵⁄₁₆ inches (26.2 cm)
Gift of the artist
1979-167-12
Pl. 101

301

308. JAMES PRESTINI
Bowl #158, 1947
Mexican mahogany
Diameter 6½ inches (16.5 cm)
Gift of the artist
1979-167-4

309. JAMES PRESTINI
Bowl #24, 1949
Mexican mahogany
Diameter 11³⁄₁₆ inches (28.4 cm)
Gift of the artist
1979-167-10
Pl. 100

310. JAMES PRESTINI
Bowl #162, 1949
Cherry
Diameter 7³⁄₁₆ inches (18.3 cm)
Gift of the artist
1979-167-7

311. JAMES PRESTINI
Platter, 1949
Honduras mahogany
Diameter 12⁷⁄₁₆ inches (31.6 cm)
Gift of the artist
1979-167-1

312. JAMES PRESTINI
Bowl #71, 1950
Ebonized poplar
Diameter 6¹³⁄₁₆ inches (17.3 cm)
Gift of the artist
1979-167-5

313. JAMES PRESTINI
Bowl #92, 1950
Chestnut
Diameter 8⅝ inches (21.9 cm)
Gift of the artist
1979-167-8
Pl. 99

314. ROBERT STOCKSDALE
American, born 1913
Bowl, 1975
Indonesian boxwood
Diameter 8⅛ inches (20.6 cm)
Gift of Ellen Plotkin and Collab: The Group for
Modern and Contemporary Design at the
Philadelphia Museum of Art
1976-107-1*

315. ROBERT STOCKSDALE
Bowl, 1986
Philippine ebony
Diameter 10¾ inches (27.3 cm)
Gift of The Women's Committee of the Philadelphia
Museum of Art
1987-49-1
Pl. 102

* Reproduced in black and white

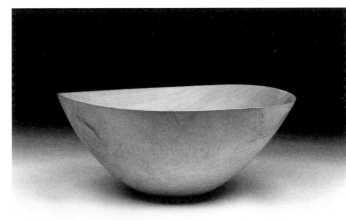

314

INDEX OF ARTISTS